The Thought of the Heart
and
The Soul of the World

JAMES HILLMAN

Spring Publications, Inc.
Dallas, Texas

Second printing 1993. Published by Spring Publications, Inc., P.O. Box 222069, Dallas TX 75222. Printed in the United States of America on acidfree paper
Cover design and production by Margot McLean

Library of Congress Cataloging-in-Publication Data

Hillman, James.
[Thought of the heart]
The thought of the heart ; and, The soul of the world / James Hillman.
p. cm.
Includes bibliographical references.
ISBN 0-88214-353-0 (paper)
1. Archetype (Psychology) 2. Heart—Psychological aspects--History. 3. Imagination—History. 4. Environmental psychology.
5. Human ecology—Psychological aspects. 6. Panpsychism--Psychological aspects. 7. Psychotherapy. I. Hillman, James. Anima mundi. 1992. II. Title. III. Title: Soul of the world.
BF175.5.A72H55 1992
150.19'5—dc20 92-13675
 CIP

CONTENTS

ACKNOWLEDGMENTS

"The Thought of the Heart" is derived from a lecture given at the Eranos Conference in Ascona, Switzerland, in 1979. An earlier version appeared in the *Eranos Yearbook* 48—1979 (Frankfurt am Main: Insel Verlag), pp. 133–82. With the kind permission of the Eranos Foundation, it was reprinted in 1984 and 1987 as a small book *The Thought of the Heart* (Dallas: Spring Publications).

"Anima Mundi: The Return of the Soul to the World," slightly revised here, was first published in *Spring 1982: An Annual of Archetypal Psychology and Jungian Thought*, pp. 71–93. It was originally delivered in Italian translation as a lecture at the Palazzo Vecchio, Florence, Italy.

THE THOUGHT OF THE HEART

Speech is not of the tongue, but of the
heart. The tongue is merely the instru-
ment with which one speaks. He who is
dumb is dumb in his heart, not in his
tongue. . . . As you speak, so is your
heart.

<div align="right">Paracelsus</div>

I. The Captive Heart

Y ou who have been privileged at some time during his long life to have attended a lecture by Henry Corbin have been present at a manifestation of the thought of the heart. You have been witness to its creative imagination, its theophanic power of bringing the divine face into visibility. You will also know in your hearts that the communication of the thought of the heart proceeds in that fashion of which he was master, as a *récit*, an account of the imaginal life as a journey among imaginal essences, an account of the essential. In him imagination was utterly presence. One was in presence of imagination itself, that imagination in which and by which the spirit moves from the heart toward all origination.

You also have already seen and heard the themes that I shall be attempting in this essay as they were embodied in the physical intensity of that living man, Henry Corbin: the thought of the heart as

sovereign and noble, as joyous, as subtle as an ani-
mal, bold, courageous and encouraging, as delight-
ing in intellectual forms and fierce in their defense,
ever-extending equally in its compassion and in its
visionary power, forming a beauty in the language
of images.

Because of what he has done in his work—and
is continuing to do, since the presence of a person
does not depend only on his visibility, the invisible
Henry Corbin is among us—because of him, the
basis of our work has already been done. We do not
have to establish the primary principle: that the
thought of the heart is the thought of images, that
the heart is the seat of imagination, that imagina-
tion is the authentic voice of the heart, so that if
we speak from the heart we must speak imagina-
tively. Because the primary principle has already
been given by him, we may explore tributaries of
the main stream.

Our job will be less to inspire the heart by recita-
tions of life in the imaginal, as he did, and more
to rediscover the heart in its immediate actual imag-
inings, in its exile, in an imagination which Corbin
calls "captive" (*SB:* 146), where the thought of the
heart has become adulterated in our contemporary
heart diseases: sentimentality of personalism, bru-
talism of efficiency, aggrandizement of power, and
simple religious effusionisms.

It was Henry Corbin's gift to enable us to ex-

perience thoughts that come from another language and culture as if they were of our own hearts. He spoke from within his speech; he was his words. This rhetorical imaginative power is *himma* of which Corbin writes in his study of Ibn 'Arabi:[1]

> This power of the heart is what is specifically designated by the word *himma,* a word whose content is perhaps best suggested by the Greek word *enthymesis,* which signifies the act of meditating, conceiving, imagining, projecting, ardently desiring—in other words, of having (something) present in the *thymos,* which is vital force, soul, heart, intention, thought, desire. . . . (*CI:* 224)

As he goes on to explain, this *himma,* the thought of the heart in Ibn 'Arabi, is so powerful as to make essentially real a being external to the person who is in this condition of *enthymesis. Himma* creates as 'real' the figures of the imagination, those beings with whom we sleep and walk and talk, the angels and daimones who, as Corbin says, are outside the imagining faculty itself. *Himma* is that mode by which the images, which we believe we make up, are actually presented to us as not of our making, as genuinely created, as authentic creatures. And, as Corbin goes on to say, without the gift of *himma* we fall into the modern psychological illusions. We mis-

understand the mode of being of these images, the figures in our dreams or the persons of our imaginings. We believe these figures are subjectively real when we mean *imaginally* real: the illusion that we made them up, own them, that they are part of us, phantasms. Or, we believe these figures are externally real when we mean *essentially* real—the illusions of parapsychology and hallucinations. We confuse imaginal with subjective and internal, and we mistake essential for external and objective.

We cannot go further without this background in Corbin, because we are bereft in our culture of an adequate psychology and philosophy of the heart, and therefore also of the imagination. Our hearts cannot apprehend that they are imaginatively thinking hearts, because we have so long been told that the mind thinks and the heart feels and that imagination leads us astray from both. Even when the heart is allowed its reasons, they are those of faith or of feeling, for we have forgotten that philosophy itself—the most complex and profound demonstration of thought—is not 'wisdom' or 'truth' in an abstract sense of 'sophic.'[2] Rather, philosophy begins in a *philos* arising in the heart of our blood, together with the lion, the wound, and the rose. If we would recover the imaginal we must first recover its organ, the heart, and its kind of philosophy.

Philosophy enunciates the world in the images of words. It must arise in the heart in order to mediate

the world truly, since, as Corbin says, it is that subtle organ which perceives the correspondences between the subtleties of consciousness and the levels of being. This intelligence takes place by means of images which are a third possibility between mind and world. Each image coordinates within itself qualities of consciousness and qualities of world, speaking in one and the same image of the interpenetration of consciousness and world, but always and only as image which is primary to what it coordinates. This imaginational intelligence resides in the heart: "intelligence of the heart" connotes a simultaneous knowing and loving by means of imagining.

If such philosophy is an event of the heart, events of the heart may be conceived as philosophic. The heart's work is imaginational thought, even if disguised in philosophies that seem without images and without heart. This imaginational thought can even be disguised in philosophies or psychologies of its own nature, that is, in theories of the heart. We shall have to turn to some of these in order to recover from those disguises a true philosophy originating in the imaginal heart itself, the heart of Corbin.

But first we must relate the imaginal heart of Corbin with the heart of depth psychology, of Freud. For Freud provides the paradigmatic occasion for the appearance of the thought of the heart within

that Western modern consciousness which is bereft of a philosophy for adequately meditating its own heart. Though the relation of Freud to Corbin may seem strained, it is worth every effort, for Corbin can save Freud from the Fall, from reduction downward. The relation allows us to look at Freud always with the imaginal eye of Corbin.

For instance: the beginnings of psychoanalysis are marked by two signal events. Looking at them with the eye of Corbin we can see them as having the same source. These events, you will remember, are the fact that the very first patient whom Freud's colleague Josef Breuer treated by the new method fell so in love with the good old doctor, that it—this transference as it came to be called—drove Breuer out of psychoanalysis for ever.

The second event was that, as the patients unburdened their hearts in detailed memory images, their stories moved from fact to fiction, from mundane recollections to fantastic inventions (*in-venio* = incursions, comings in), from history to imagination.

Love and imagination entered psychoanalysis at the same moment. From its inception psychoanalysis raised the *thymos* of the heart—which it called wishing, *Wunsch*—to priority as an explanatory principle. The patient was a creature of *enthymesis* in whom the *himma* was awakening. And the presence

of the analyst, Freud or Breuer, became the first car-
rier of the imaginal figures. Transference, yes; but
from where transferred? Not childhood and the
downward reduction only, but Platonic childhood,
and the a priori remembrance of imaginal presences
transferred with us into this life and the source of
its love.

When we fall in love, we begin to imagine; and
when we begin to imagine, we fall in love. To this
day, depth psychology is caught by the necessary
connection of love and imagination which it has not
yet had the philosophy to place. It has not yet read
Corbin as a classic of psychoanalysis. It has stum-
bled into the heart without a philosophy of its
thought.

Now to the disguises. When in our exile we stand
in the contemporary heart and imagine from it, our
images move in several directions, each one a
philosophy about the heart. Let us review these com-
monplace imaginings as expressions of the heart in
our culture.

First: my heart is my humanity, my courage to live,
my strength and fierce passion. By means of it
nothing is foreign to me;[3] all can be admitted to its
kingdom of dignity. My most noble virtues emanate
from the heart: loyalty, heroic boldness, compassion.
Let us call this the heart of the Lion, Coeur de Lion.

Second: my heart is an organ of the body. It is a

muscle or a pump, an intricate mechanism and secret holder of my death. Let us refer to this pumping heart as the heart of Harvey.

Third: my heart is my love, my feelings, the locus of my soul and sense of person. It is the place of intimate interiority, where sin and shame and desire, and the unfathomable divine too, inhabit. Let us call this personal heart, the heart of Augustine.

COEUR DE LION

The first of these hearts comes from folklore, astrology, symbolic medicine, physiognomy. The heart of the lion is like the sun: round and full and whole. The classical symbolisms of this heart are gold, king, redness, *sol,* sulphur, heat. It glows in the center of our being and radiates outward, magnanimous, paternal, encouraging.

Ficino said that the nature of the heart is warm and dry and that warmth has best conformity with the universe. The thought of the lion warms so to life, is so in conformity with the world, that its thought is one with will, displaying itself in the world, enthroned as king, yellow as daylight, loud as a roar, fixed as dogma. Thought presents itself as volition, as mood, or as love, vitality, power, or imagination, and does not recognize itself as thought because it is not reflexive ratiocination, abstracted away from life, introspective.

Crucial to the heart of the lion is that it *believes,* and it believes that it does not think. So its thought appears in the world as project, desire, concern, mission. Thinking and doing together. This is the bold thought that takes us into battle, for Mars rides a red lion, and the heroes—David, Samson, Hercules—must meet the ravenous hunger for the world of deeds fulminating in their expansive chests.

So, the first basic characteristic of the *coeur de lion* is that its *thought does not appear as thought* because it emanates like the sun into the world and remains disguised in that conformity with its motion.

A second fundamental trait of this cardiac consciousness has been described by D. H. Lawrence in his symbolic physiology:

> At the cardiac plexus . . . there in the center of the breast, we have a new great sun of knowledge and of being. . . . Here I only know the delightful revelation that you are you. The wonder is no longer within me, my own dark, centrifugal exultant self. The wonder is without me. The wonder is outside me. . . . I look with wonder, with tenderness, with joyful yearning towards that which is outside me, beyond me. . . . [4]

The utter otherness of its direction, this movement outward and beyond, produces what Jung has called the "dark body" at the core of ego-consciousness, its blindness to itself. For, not only does this heart not know that it thinks, but its thought is completely coagulated into its objectifications. So wholly is its love and will one, itself and other one, itself and God one, that its vision of the cosmos is monistic and monarchical,[5] one *arche*, monotheistic, and the heart always whole. Monarchical wholeheartedness charac-

terizes its typical psychopathology, the psychopathology of *intensity:* the heart's own rhythmic systole and diastole, magnified, become intensely singled, one-sidedly either manic or depressive, generous or selfcentered, roaring or lazy.

Thus, the task of consciousness for the *coeur de lion* lies in recognizing the archetypal construct of its thought, that its actions, desires, and ardent beliefs are all imaginations—creations of the *himma*—and that what it experiences as life, love, and world is its own *enthymesis* presented outside as the macrocosm.

Alchemical psychology remarkably condenses the two traits of the lion-heart—the conformity of its thought and its objectification—into the alchemical substance sulphur,[6] the principle of "combustibility,"[7] the *magna flamma.* "Where is the sulphur to be found?" asks Kramer, a fourteenth-century English Benedictine. "In all substances, all things in the world—metals, herbs, trees, animals, stones, are its ore."[8]

Everything that suddenly lights up, draws our joy, flares with beauty—each bush a God burning: this is the alchemical sulphur, the flammable face of the world, its phlogiston, its aureole of desire, *enthymesis* everywhere. That fat of goodness we reach toward as consumers is the active image in each thing, the active imagination of the *anima mundi* that fires the heart and provokes it out.

At the same time that sulphur conflagrates, it also coagulates; it is that which sticks, the mucilage, "the gum," the joiner, the stickiness of attachment.[9] Sulphur literalizes the heart's desire at the very instant that the *thymos* enthuses. Conflagration and coagulation occur together. Desire and its object become indistinguishable. What I burn with attaches me to it; I am anointed by the fat of my own desire, captive to my own enthusiasm, and thus in exile from my heart at the very moment I seem most to own it. We lose our soul in the moment of discovering it: "Sweet Helen," says Marlowe's Faustus, "make me immortal with a kiss./Her lips suck forth my soul: see where it flies!" Hence Heraclitus had to oppose *thymos* and *psyche:* "Whatever *thymos* wishes, it buys at the expense of soul" (D.-K.: 85).

Psychology now calls this love in the heart of the lion compulsive projection. The alchemical basis of this kind of projection is actually the sulphur in the heart that does not recognize it is imagining. The objective *himma* is literalized into the objects of its desire. Imagination is thrown outward, ahead of itself. And so the task is less to take back these kinds of projections (who takes them back and where are they put?) but more to leap after the projectile[10] reclaiming it as imagination, thereby recognizing that *himma* demands that images always be experienced as sensuous independent bodies.[11] There are styles of projection: it is not a unitary mechanism. Cor-

dial projection requires an equally leonine mode of consciousness: pride, magnanimity, courage. To desire and to see through desire—this is the courage that the heart requires.

As Jung says: "Sulphur represents the active substance of the sun . . . the motive factor in consciousness, on the one hand will and on the other compulsion."[12] Compulsion becomes will through courage; it is in the heart that the operations upon sulphur are performed. We shall come back to these operations in the second part. For now it is enough to recognize compulsive projection to be a necessary activity of the sulphur, as the way in which this heart thinks, where thought and desire are one.

The unitary, wholehearted thought of this heart presents psychology with an animal mode of reflection. This reflection—in which imagination and perception, thinking and feeling, self and world are one—is not a bending back, after the event and away from it. Instead, the reflection occurs with the perception as its sheen and luster, the play of *its* lights rather than the light of the consciousness which I bring to it, each thing immediately reflecting its image in the perceiving heart—mental reflection foreshortened to animal reflex.

The animal heart directly intends, senses, and responds as a unitary whole. Wholeness in the act, as a quality of the act. This heart we find first elaborated in Aristotle who described it as the hottest

bodily part (493a3, 743b27, 744a29) and the central source of our blood and our organic heat (667b17, 665b32, 766b1). It senses and responds directly, for the organs that sense the world run to the heart (781a21, 647a25ff., 703b24, 743b26), and especially taste[13] and touch provide this immediate connection of the heart with the world.

Aristotle's formulation of the *coeur de lion* in his physiology of perception compares with that of the Paracelsians. They conceived the microcosmic heart in our breasts to be the place of imagining, which imagination conforms with the macrocosmic heart of the world, the sun. The animal heart here bespeaks the animal sun there in an animated world.[14] The world is a place of living images, and our hearts are the organs that tell us so.

If the heart is the place of images, a heart infarction refers to a heart stuffed (*farctus* = stuffed, crammed, filled, fattened) with its products, imaginings. It is clogged by its own sulphuric riches that have not gone into circulation. Either they have been constrained by narrowings and not been allowed passage, or they have been seen only as literal actions-in-the-world, instead of also as imaginings of the heart, belonging to its interior circulation. This same literalism of the heart's sulphur returns in the very theories of heart disease, where fat, narrowing of circulation, deed-in-the-world (type A personality) reappear as explanations. These ex-

planations say that we are attacked by our own lion in the breast, our heart full of *himma,* whose "*magna flamma*" insists that *enthymesis* never cease, that each particular throb of the heart devours our life and can only be cured if recognized as a thought of the heart.

THE HEART OF HARVEY

Harvey's volume on the heart, seventy-two quarto pages in Latin, printed in Frankfurt in 1628 when Harvey was fifty years old, is called (in English translation) "An Anatomical Dissertation concerning the Motion of the Heart and Blood in Animals." Its key idea, presented with meticulous verification and excellent reasoning, had already been recorded by him as early as 1616 in notes for lectures given in London at the College of Physicians. In these notes he states that the "perpetual motion of the blood in a circle is brought about by the beat of the heart."[15]

The motion of the blood in a circle is an archetypal idea. Similar depictions have been attributed to Huang-ti in China[16] in the third millennium before our era and deduced from Egyptian papyrus of the Old Kingdom.[17] Besides, Fludd, Cesalpino, Servetus, da Vinci, and Valverde have each good reason to be called forerunners of Harvey. Giordano Bruno wrote (*De Rerum Principiis,* 16 March 1590): ". . . the blood in the animal body moves in a circle in order to distribute its motor."[18] In Act I, Scene 1 of *Coriolanus,* Shakespeare's play conventionally dated 1609, compact with words such as "state" and "honour" and in which we find images of lions, courage, rage and anger, proudness and nobility, we

also find this metaphor of the blood's circulation (moving from a central organ): "I send it through the rivers of your blood, even to the court, the heart, to the seat of the brain;/And, through the cranks and offices of man,/The strongest nerves and small inferior veins/From me receive that natural competency/Whereby they live."[19] Circulation of the blood was in the Zeitgeist of the early seventeenth century.

Harvey still maintains the archetypal images of our first heart, that of the King. His little book opens with a dedication to Charles the First, comparing the King in his Kingdom with the heart in the midst of the body; and the book concludes with this passage: ". . . the heart like a prince in a kingdom, in whose hands lie the chief and highest authority, rules overall; it is the original and foundation from which all power is derived, on which all power depends in the animal body."[20] But Harvey's heart differs essentially from that older heart of lion and feeling, because his is a heart of visible demonstration. Harvey tells how the valves work, how the chambers and veins function. His crucial demonstration that the blood must circulate combines visible evidence (ligature of blood vessels so as to show the differences between veins and arteries) and quantitative mensuration. If the pulse, he asks, beats 72 times a minute, in one hour the left ventricle will throw into the aorta no less than $72 \times 60 \times 2$ or 8640

ounces of blood, that is, 38 stone 8 pounds, which
is three times the weight of a heavy man! Where can
all this blood come from? Where can it all go to?
It must be the same blood in continuous circula-
tion, leaving the heart and returning to it. And how
does this heart work? Like a water bellows, he says;
our pulse is a pump.[21] What pounds in our ears,
throbs in our groins, is the beat of a machine.

Hold it in your hands, he explains: ". . . it may be
felt to become harder during its action. This hard-
ness proceeds from tension, just as when the fore-
arm is grasped, its muscles . . . become tense and
firm when [these muscles] move the fingers . . . dur-
ing action the heart . . . becomes erect, hard and
smaller. . . . the movement is plainly of the same
nature as that of the muscles when they contract"
("Anatomical Dissertation," pp. 1–2).

This is all new: this hardness of the heart, this
smallness, this muscular tense heart, inherently
stressed, this pumping machine, demonstrated so
directly and tangibly—hold it in your hands. We can
take the heart in our hands. As the phenomenologist
Robert Romanyshyn has indicated in his lectures
about Harvey's vision, the scientific outlook requires
the kind of heart it sees. The act of demonstration
creates what it demonstrates. An invisible heart of
himma and the courageous heart of the lion cannot
be held in the hand, nor can the volume of their
sanguinity be computed.

The approach to the heart by means of literal sense perception creates the mechanical heart that Harvey describes. *Himma* is at work even in science—indeed in scientific thought perhaps more than anywhere—because what is imagined by science is presented as if objectively real and independent of a subjective imagination. The scientific imagination is *himma* literalized.

With Harvey, we are not only in the new scientific age; we are in a new world-order where the lion no longer rules. The end of the animal kingdom, the kingship of and kinship with the animal. Our animal selves become symbolic lore or history or evolution, but no longer actual and present; Harvey's praise for Aristotle, Galen, and Fabricius, and the King too, is now only tribute to the past and the great. The heart as the King is now a pretty way of speaking, a conceit. The past is a rhetorical flourish appropriate to opening and closing a book, but incidental to its body—and our body. Tradition has now become history, history of medicine, as if the heart were not the same heart, always. Let us take note: the evisceration of tradition takes place when the heart loses its relation with organic nature, its empathy with all things, when the core of our breast moves from an animal to a mechanical imagination.

When the great tradition becomes only the past from which we evolve, then the stage is set for Darwin and the progressive evolution away from the

animal. Descartes, La Mettrie—the animal as machine. And the stage is set for the end of the divine rightness of Kings and the new kingdom of man, humanism. The heart itself shifts from royal rule to the common heart of sentiment, the fraternity of feeling that accompanies the machine as its counterpart.

The transfiguration of our Western culture into an industrial egalitarianism with materialistic values first required Harvey's transformation of the heart. The king had first to become a machine, and the machine become a spare part, interchangeable from any chest to any other. Of course, the heart soon reacted: already by 1654 Pascal was converted to the heart of faith and feeling, and in 1673 Margarite-Marie Alacoque, since sainted, began her series of extraordinary visions on which is based the Catholic doctrine of the Sacred Heart. The Feast was allowed a hundred years later, in 1765, just after Rousseau published *Émile*.

History is psychology because tradition is always going on in the soul. The mechanical heart and the sentimental heart still imply each other, still require each other, and neither remembers the lion.

Today, each of us carries the Harveyein heart in our breasts: my heart is a pump. It has thick muscular walls that need exercise. If it fails, I put in a pace-maker or some bypass tubing. If it wears out, irreparably, I can let that heart doctor, named

paradoxically enough, Christian Barnard, remove it and replace it with a spare—an operation, by the way, already presaged by St. Catherine of Siena who prayed and was vouchsafed that prayer that her heart be removed and that of the Savior placed in her breast.

To keep my ticker running, I jog it. The heart must be lean, trim, erect, so I watch for extremes of intensity, like idle leisure, and of abuse, like passionate excitement. Now, the heart is no longer the animal of love and heat, the place of *himma,* throbbing out its imaginative forms. Now, its signals are decoded into little messages about life-expectancy. For my heart can insult me, attack me. I must propitiate it: I take this for my heart, do that for my heart, watch out for my heart. I turn it in regularly for a checkup. The mechanical model, by means of which I watch the heart as if it were a dead thing outside me, moves with technological progress from Harvey's water-bellows, to the stethoscope, to the ECG attached to me by wires, my heart on a television screen. Our modes of imagining its conservation are also mechanical: unobstructed elastic channels, light viscosity of the blood, reduced pressure of blood volume against arterial walls.

The heart is still king, still the pace-maker, but now a tyrant, for heart and circulatory diseases are "the number one killers," usually striking in the night. It cannot be trusted; we cannot have faith in

the very organ which once was the source of faith. The heart has become my enemy, my killer, my death.

The dead heart was born into Western consciousness, according to Romanyshyn, at that moment when Harvey conceived the heart to be divided. He saw, down its middle, separating left from right, an impassable wall. Because of this impassable wall, the blood must necessarily be pumped through a great and complicated circulation, i.e., through the lungs and entire body in order to move to the other side of the heart.[22] Hence, it is the divided heart that makes possible the *circulatio*.

Thus Harvey confirmed Ibn Sina's notion that 'heart' is a force occupying the whole body, whose visible organ is the anatomical heart.[23] And curiously, the circulation of the blood depended (even as a scientific idea) on a radical confirmation of the *cor duplex*, a heart divided against itself. Here, Harvey affirmed an archetypal idea, that the heart is not simple, not one, but is inherently divided against itself; its left and right chambers, though side by side, are most remote to each other, without communication. We shall have to return later to this innate *dipsychos*, or duplicity of the heart. For it was here, I believe, in the visible demonstration of the inherent duplicity of the heart that the telling blow was struck against the naive *coeur de lion* and its faith in wholeheartedness. No longer could the world be

one, under one rule of sun, king, and lion. The immediacy of action became doubled into complicated reflection. Thought lost its heart, heart its thought. The king was dead, and a wall had now been set between the world out there and subjective feelings in here, because even in the center of the breast there was division.

THE HEART OF AUGUSTINE

More than the lion and the pump, it is the heart of Augustine that has most affected psychology, both as a field of thought and as everyday life where heart means feeling, my own interior nature, the secret chamber of my person. As Dietrich von Hildebrand[24] says:

> It is the heart which is the most intimate part of a person, the core, the real self. . . . (p. 109)
> It is in the heart that the secret of the person is to be found, it is here that the most intimate word is spoken. (p. 97)

Another Catholic philosopher, Paul Henry,[25] says it was Augustine who "first came into prominence and undertook an analysis of the philosophical and psychological concepts of person and personality." And the Protestant theologian Adolf von Harnack said:

> "Where in all the history of the Western Church do we encounter a man whose influence is comparable to the influence of Saint Augustine?"[26]

I wish to impress upon you Augustine's importance in developing the philosophy of the personal

feeling heart in order that we recognize that the contemporary cult of feeling as the 'true' thought of the heart is fundamentally Augustinian Christianity. We cannot confront the personalism of California without first passing through the confessionalism of Carthage.

Augustine's thought of the heart begins with his *Confessions.* This book is a testament of interior experience, the first book of psychology developing an idea of person as experiencing subject. "Person" is a word that the Greeks did not have, nor does the word appear in the Greek New Testament.[27] Augustine's use of the word *cor,* heart, equates it with *intima mea,* inward dwelling, "closet" (*En. Ps.* CXLII [2]), the anima or soul ("our shared bedroom, my heart"—*Conf.* 8.8).

Heart is essentially *my* heart: "Cor meum, ubi ego sum quicumque sum—my heart, where I am, whatever I am" (*Conf.* 10.3). It is the deepest place, an unfathomable "abyss" (one of his favorite words for heart), in which my truth resides: ". . . whose heart is seen into? What he is engaged on, what he is inwardly capable of, what he is inwardly doing or purposing, what he is inwardly wishing to happen, or not to happen, who shall comprehend?" (*En. Ps.* XLII 12 or XLI 8 [12]). Already, a psychoanalysis of feelings. Heart as inwardness—not as lion, sun, king of the body in conformity with the world.

Feelings are the way of knowing this heart, and

confession brings it to expression.[28] The thought of the heart is feeling: "Where the heart is, there is either blessedness or misery" (*De. mus.* 6.11). This heart is emotional, the place of storms and tears, of conflict, of *Gemüt* in its fullest sense: "Arise, seek, sigh, pant with longing, knock at what is shut. If we do not yet long, not yet sigh, we shall only be casting pearls. . . . Therefore, dearest beloved, I would stir up longing in your heart" (*In Joann. ev.* 18.7).

Let us notice at once that this intimate heart of feelings is not the heart of the Greeks, or of the Hebrews,[29] or of the Persian thought presented by Corbin. Corbin (*CI:* 221&n) states quite clearly that the heart's characteristic action is not feeling, but sight. Love is of the spirit, quickening the soul to its images in the heart. The heart is not so much the place of personal feeling as it is the place of true imagining, the *vera imaginatio* that reflects the imaginal world in the microcosmic world of the heart. Feelings stir as images move. Hence one has recourse to the heart—not because it is where the truth of feelings resides or where one feels one's personal soul. No. One turns to the heart because here is where the essences of reality are presented by the imaginal to the imagination. The passionate spirit of *himma* that moves through the heart is not the *passio* of personal confessional life.

Now we see what happens to the imagination in a heart of personal feeling. By personalizing the

heart and locating there the word of God, the imagination is driven into exile. Its place is usurped by dogma, by images already revealed. Imagination is driven into the lower exile of sexual fantasy, the upper exile of metaphysical conception, or the outer exile of objective data, none of which reside in the heart and all of which therefore seem heartless, mere instinct, sheer speculation, brute fact. When imagination is driven out, there remains only subjectivity—the heart of Augustine.

And this heart of subjective feeling holds imagination in its captivity. We judge our images in terms of their feelings. Whether a project or reverie be imagined further is determined by how it feels. Is this dream good or bad—feeling will tell you. To test something in the heart has come to mean what we feel about it, and to weigh the heart refers no longer to the gravity and substance of its images, but mainly to our personal motivations and reactions that can be discovered in confessional introspection.

A gulf opens between subjective feelings without imaginative forms and the literalism of images as sensations, ideas, data without subjectivity. They do not confess; only I can confess. So anything they might say must be my projections. The whole endeavor of retrieving projections—that major enterprise of analytical practice—could become irrelevant once the theory of the heart were to shift from its personalistic base. We would then recognize

much of what we call projection to be an attempt by the psyche to experience things beyond ourselves as imaginal presences, an attempt to restore both heart and image to things. Pornography, intellectual abstractions, and the impersonal data from the sciences and histories can be recovered by our taking them to heart, allowing them to invent themselves further, encouraging them to confess *their* imaginal reality.

It sounds as if our modern personalism of the heart, which we are attributing to Augustine, better belongs to Rousseau. It is Rousseau who wrote in his *Confessions:* "One must know how to analyze properly the human heart to disentangle the true feelings of nature," who also wrote there of Mme. de Warens's heart as her guide through the maze of feelings, and who, in his famous phrase from *Émile*—"Exister pour nous, c'est sentir" (pp. 252–53)—gives to the heart the rule by which all life can be measured.

Whether Augustine or Rousseau is the originator is less the issue than is the *confessional mode.* As Paul Henry says: "Augustine, interested in man, self, personality, thereby invented a new literary genre" (*Saint Augustine on Personality,* p. 12). This genre is the exposition of subjectivity, the confession, and it requires a rhetoric of the ego, the first person singular. Augustine says:

> Accept the books of my Confessions. . . . There
> see me . . . there believe, not others about me,
> but myself; there mark me, and see what I was
> in myself, by myself. . . . (*Ep. ad Darium* [Ep. 231])

The word "confession" from *fassus* bears the root *pha* (Grk) and *bha* (Skr), "show," "light," "shine." It is the confessional literary genre of showing, not Augustine or Rousseau, which creates the experience of the heart as abyss, of experience as unfathomable, one's person a closet of deep interior darkness. This same genre also creates 'Augustine' and 'Rousseau' as necessary figures of the mode, heroes of the psychological. They are first person singulars, the feeling, suffering personalities, who perform the heroic task of bringing light out of their personal abyss. As soon as we start to confess, we enter this genre, and then we must struggle with finding the true 'me' hidden in the closet of personal feelings.

Here, confessional psychology literalizes the notion of revelation as a bringing to show what therefore must be concealed, light out of darkness, subjective heroics. Confessional psychology misses the fact that I am already revealed in my *Selbstdarstellung*. Revelation already given with existence—not a task. Every move we make, phrase we utter, is confession of our heart because it reveals our images. Heart is manifest in the fantasies dis-

played in my life, not only concealed in my depths. In this way, confessional psychology subtly devalues the presentation of self in everyday life, which for Augustine belongs anyway merely to the "exterior."

The truths of the heart do not have to be stated or even experienced as *my* feeling. When Empedocles (frg. 115) describes the wandering, tormented souls in exile, and even confesses himself among these ("In that brood I too am numbered now"), it is a statement of the elements, an elemental statement about all souls, not a confession of his own life and heart. When Aristotle discusses catharsis and tragedy, or the nature of friendship and of courage, it is of all humans, an archetypal reflection, requiring no subject to the sentence, no rhetorical ego. When Sophocles presents the feelings of the heart in Oedipus, Antigone, Electra, or Philoctetes, these are figures of the imaginal whose dramas are staged also in my heart which mirrors macrocosmic life.

The heart can be disentangled from confessional personalism. We can be moved powerfully without confessing these movements to be our own. Empedocles, Aristotle, and Sophocles provide examples of the tragic, mythic mode of affective detachment. Another mode is the *récit,* or recitation, such as we find collected in Corbin's writings.

The difference between the confession and the recitation lies precisely in coming to a new realiza-

tion of "experience." Confession confines experience to 'my' experience—what is registered in my nature. As long as experience means personal felt-experience, it requires the genre of confession, whether in depth psychology or in the arts, as subjectivism, expressionism, and personal romanticism. Feelings become crucial: my feelings *are* my heart. To discover its thought, I must reveal just what I feel.

The *récit*, however, is an account of events experienced, rather than of my experiencing. It was then unfolded; the angel then said; a mountain, a room, a colored light, a figure shone in splendor.[30] Like a walk through the world, there is this and this and this; the colors and shapes of the things illumined, their faces, are the confession—it is *their* coming to light, *their* testament, and *their* individuation, as Corbin said, not mine. The angel before the feeling he brings. Feelings are accessory to them, received from them. They are "divine influxes," as Blake said, moving through the heart in the company of images.

The *récit* also breaks up that identification with experience which confession reinforces: confession as possession, *my* sins. What I confess to, I must believe as truth, as history. "I did this, felt that, wished and wanted." But ever since Freud we know that what goes on in the heart is neither truth nor history; it is desire and imagination. So, confession raises the problem of *Wahrheit* and *Dichtung*. When-

ever we attempt to tell our feelings—what I really feel, what was my true motive—a certain duplicity starts up. Truth or Fiction? We are in the midst of Harvey's *cor duplex:* we waver at the very moment we own up.

Again the problem is rhetorical: the first person singular implies a single feeling. The reporter is singular whereas the feelings are multiple. So, to get to the heart's core, we become fanatically confessional, intensely personal, letting it all show forth in order to get to this fictional, rhetorical 'true inside real feeling me.'

Confession supports one of our most cherished Western dogmas, as Gilbert Durand and David Miller have both said: the idea of a unified experiencing subject vis-à-vis a world that is multiple, disunited, chaotic. The first person singular, that little devil of an I—who, as psychoanalysis long ago has seen, is neither first, nor a person, nor singular—is the confessional voice, imagining itself to be the unifier of experience. But experience can also be unified by the style in which it is enacted, by the images which form it, by its repetitive thematics, and by the relations amid which it unfolds. It does not have to be owned to be held. The heart in the breast is not your heart only: it is a microcosmic sun, a cosmos of all possible experiences that no one can own.

This problem of the experiencing subject holding the world together is not merely a language game,

the grammar of the first personal singular creating ontology. It is more seriously a confessional ontology of the personalistic heart dominating our grammar, persuading us by our very sentence structures that when our pronoun is singular then so must be our verbs; our actions too must be single. The subject/predicate construction holds apart 'I' and everything else; whatever is not I becomes predicated of the subject. Imagine: we feel in such a way that this I, this me, is separate and over against the huge full world, as if a pair of equal co-ordinates.

In the practice of religion, confession is immediately followed by prayer. Recognition and repentance are not therapeutic enough; confession corrects personal experience, but does not remove us from it. Augustine recognized that confession becomes mere autobiography unless it is as well a devotion to the divine in the heart. Rousseau, too, located his divinity, "nature," in the heart, which gives to both their confessions the testimony of religion.

Psychotherapy stops short. It invites confession but omits prayer. The religious impulse is provoked and then unsatisfied. A secondary religious aura then pervades many aspects of psychotherapy. Analysis itself is regarded religiously; "experience" is endowed with religious values, becoming sacred, unavailable to examination: the Dogma of Experience. The emotions of the heart are taken for religious revelations.

Confession is an initiatory stage of psychotherapy, as Jung said (*CW* 4: ¶¶431–35; 12: ¶3; 16: ¶153). But because confession fails to carry beyond itself, it turns therapy into an addictive repetition. Rather than releasing images to flow to and from the heart as independent realities, confession fixes them there. The image is imprisoned in its feeling, rather than the feeling released into its images.

Prayer offers a therapy of confession. By praying we move out. As Coleridge[31] insisted, the intensity of Western subjectivism requires a personal divinity to whom we address our hearts. We are saved by these divinities, psychologically, for we are saved from the personalism of feeling by bringing those feelings to persons who are not we, who are beyond our notion of experience. They who are they. They who give experience and are its ground, so that the *himma* in the heart recognizes them, and not ourselves, as the true Persons. We talk to them, they to us,[32] and this "dialogical situation" (*CI:* 247) which constitutes prayer (in distinction to worship, idolatry, ecstasy) as a psychological act is, in Corbin's words (*CI:* 248), "the supreme act of the Creative Imagination."

By means of such prayer, the heart can move from those limited persons and powers—the dialogical situation of the analyst and the patient, their mutual feelings, their transferences. Secular therapy has transferred onto these human figures and the move-

ments of their hearts the imaginal figures of prayer. Transference is the ultimate consequence of secularized confession, and the resolution of transference, as Jung said, is a religious care with the impersonal, the persons of the imaginal. Transference, the mystery of therapy, can be moved only when we move the heart from its confessional mode of experiencing to a prayerful response to its images—witnessing; Corbin's *récit*.

The response to these persons begins in an activated imagination, in *himma*, the heart's ardent witness to imaginal persons independent of the heart which beholds them. Not held; beheld, and we beholden to powers; we in their luminosity, watched by them, guarded, remembered; visible presences, enlightening our darkness by their beauty.

II. The Heart of Beauty

When Petrarca, age twenty-two, in the Church of
Santa Chiara at Avignon, on 6 April 1327, caught
sight of a lovely girl, his heart pounded or stopped
or leapt into his throat. His soul had been assailed
by beauty. Was this when the Renaissance began?
Or had it already begun, this Vita Nuova, when
Dante, in 1274 at the age of nine, first saw Beatrice
("she who confers blessing"), crimson-dressed girl-
child and *anima mundi,* awakening his heart to the
aesthetic life.

"At that moment," writes Dante, "I say . . . the spirit
of life, which hath its dwelling in the secretest cham-
ber of the heart, began to tremble so violently that
the least pulses of my body shook; and in tremb-
ling it said these words: 'Here is a deity stronger than
I; who, coming, shall rule over me' " (*Vita Nuova,* II).
From then on he was a devotee of this deity in the
shape of his soul figure, dedicated to love, imagina-
tion, and poetic beauty, all three inseparably.

These couples, Petrarca and Laura, Dante and Beatrice, had no personal satisfaction, no human relationship. Yet what emerged from these happenings in the heart was the transformation of all Western culture, commencing as an aesthetic transformation; it was generated by Beauty. Was not Psyche in the Apuleius tale singled out by her beauty, and is not Aphrodite, the Beautiful One, the soul of the universe *(psyché tou kosmou* or *anima mundi)* that produces the perceptible world according to Plotinus (III.5.4) and also the soul of each of us?

Can we attend to what these figures and tales are saying? Can we realize that we are each, in soul, children of Aphrodite, that the soul is a *therapeutes,* as was Psyche, in the temple of Venus—*that* is where it is in devotion. The soul is born in beauty and feeds on beauty, requires beauty for its life. If we read Plato the way Plotinus did, and understand Psyche the way Apuleius did, and experience soul as did Petrarca and Dante, then *psyche is the life of our aesthetic responses,* that sense of taste in relation with things, that thrill or pain, disgust or expansion of breast: those primordial aesthetic reactions of the heart are soul itself speaking. Psyche's first trait, and the way we know her first, is neither by her labors, the *work* of soul-making, nor by her sufferings for love, nor in her oppression in lostness, the absence and deprivation of soul—these in the Apuleian tale all come later. We know her first by her primary

characteristic given with her nature: Psyche is beautiful.

How is it possible that beauty has played such a central and obvious part in the history of the soul and its thought, and yet is absent in modern psychology? Imagine—decades of depth psychology without a thought to beauty! Even now psychology tends to reduce the aesthetic from its primacy to a diagnostic attribute, "aestheticism."[33] Those tales of Petrarca and Dante become anima fascinations, immature idealizations of repression, unrelated narcissism, typically puer aestheticizing.

We have taken Psyche's beauty only symbolically as meaning something other than itself. We have not read carefully what Apuleius says nor placed it against his Platonic background. Else we would have understood that Psyche's beauty was visible, sensate,[34] as Laura's was to Petrarca, as Aphrodite shows herself nude. Moreover, in our psychological interpretations of Psyche (Neumann, von Franz, Hillman, Ulanov[35]) we have mistaken her beauty as a mere motif to be understood, rather than as the essential characteristic of Psyche's image, a mistake which requires a new reading of the tale in terms of the soul's essentially aesthetic nature.

If beauty is not given full place in our work with psyche, then the soul's essential realization cannot occur. And, a psychology that does not start in aesthetics—as Psyche's tale starts in beauty and as

Aphrodite is the *psyché tou kosmou* or soul in all things—cannot claim to be truly psychology since it omits this essential trait of the soul's nature. We are led already to see that a full depth psychology expressing the nature of Psyche must also be a depth aesthetics. Further, if we would recuperate the lost soul, which is after all the main aim of all depth psychologies, we must recover our lost aesthetic reactions, our sense of beauty.

So, in what follows we shall be entering another mode of the heart's thought, an exegesis of the heart that might lead it and us from the captivity in the modes we previously examined. Our theme is the thought of the heart as the aesthetic response.

By beauty we do not mean beautifying, adornments, decorations. We do not mean aesthetics as a minor branch of philosophy concerned with taste, form, and art criticism. We do not mean "disinterestedness"—the lion asleep. Nor can beauty be held in museums, by maestros at the violin, a profession of artists. Indeed we must cleave beauty altogether away from art, art history, art objects, art appreciation, art therapy. These are each positivisms: that is, they posit beauty into an instance of it; they position *aisthesis* in aesthetic events such as beautiful objects.

In pursuing what we mean by beauty we are obstructed by the word "beauty" itself. It strikes the ear as so effete, so ineffectual, lovely and etheric, so

far removed from the soul's desperate concerns. Again we see how our notions are determined by archetypal patterns, as if beauty had become relegated only to Apollo, the examination of invisible forms like music, belonging to collectors and subject to disputes in journals of aesthetics. Or, beauty has been given over wholly to the soft hands of Adonis and Paris, beauty as violets, mutilation, and death. In Plato and Plotinus, however, beauty does not have this glabrous, passive, and ungenerative sense at all, and it is rarely brought into relation with art. In fact beauty is not 'beautiful,' and Socrates' person is witness. Rather, the beautiful in Platonic thought can only be understood if we can enter an Aphroditic cosmos, and this in turn means penetrating into the ancient notion of *aisthesis* (sense-perception) from which aesthetics derives.

We must press beyond our usual ideas of beauty that have held the imagination captive to heavenly notions only, Aphrodite Urania, and away from the world of sense in which Aphrodite was always immanent. Hence, her nakedness has been pornographized by denigrating the visibility of physical appearance. As well, these lofty ideas have mystified revelation into an eschatological expectation: revelation comes as an epiphany that must shatter the sensate world only when we cannot sense the revelation in the immediate presentation of things as they are.

As Corbin writes (*ML:* 103), beauty is that great category which specifically refers to the *Deus revelatus,* "the supreme theophany, divine self-revelation." As the Gods are given with creation so is their beauty in creation, which is the essential condition of *creation as manifestation.* Beauty is the manifest *anima mundi*—and do notice here it is neither transcendent to the manifest or hiddenly immanent within, but refers to appearances as such, created as they are, in the forms with which they are given, sense data, bare facts, Venus Nudata. Aphrodite's beauty refers to the luster of each particular event— its clarity, its particular brightness: that particular things appear at all and in the form in which they appear.

Beauty as Plato describes it in the *Phaedrus* (250b) is the manifestation, the showing forth of the hidden noumenal Gods and imperceptible virtues like temperance and justice. All these are but ideas, archetypes, pure forms, invisible didactic talk unless accompanied by beauty. "For beauty alone," he says, "this has been ordained, to be the most manifest to sense. . ." (250d). Beauty is thus the very sensibility of the cosmos, that it has textures, tones, tastes, that it is attractive. Alchemy might call this cosmic gloss, sulphur.

Here we must recall that *kosmos* originally in Greek was an aesthetic idea, and a polytheistic one. It referred to the right placing of the multiple things of

the world, their ordered arrangement. *Kosmos* did not mean a collective, general, abstract whole. It did not mean universe, as turning around one point (*unus-verto*) or turned into one. This translation of cosmos into universe is a typical Roman imperialism unifying and obliterating the Greek particular sense of the world.

Kosmos also implied aesthetic qualities such as becomingly, decently, duly, honorably, creditably. "Cosmetics" is closer to the original meaning than is our word "cosmic" (as vast, unspecified, empty). *Kosmos* was used especially of women in respect to their embellishments; the Stoics used the word for the *anima mundi*. That today "cosmic" has come to mean unimaginable and vague outer space only tells us further what has happened to Aphrodite Urania when severed from her sensate counterpart Pandemos.

If beauty is inherent and essential to soul, then beauty appears wherever soul appears. That revelation of soul's essence, the actual showing forth of Aphrodite in psyche, her smile,[36] is called in mortal language "beauty." All things as they display their innate nature present Aphrodite's goldenness; they shine forth and as such are aesthetic. Here, I am merely restating what Adolf Portmann has elaborated at Eranos for forty years: the idea of *Selbstdarstellung* (self-presentation) as the revelation to the senses of essential *Innerlichkeit* (interiority). Visible

form is a show of soul. The being of a thing is revealed in the display of its *Bild* (image).

Beauty is not an attribute like a fine skin wrapped round a virtue, merely the aesthetic aspect of appearance. It is appearance itself. Were there no beauty, along with the good and the true and the one, we could never sense them, know them. Beauty is an *epistemological* necessity; it is the way in which the Gods touch our senses, reach the heart, and attract us into life.[37]

As well, beauty is an *ontological* necessity, grounding the sensate particularity of the world. Without Aphrodite, the world of particulars becomes atomic particles. Life's detailed variety is called chaos, multiplicity, amorphous matter, statistical data. Such is the world of sense without Aphrodite. Then sense must be made of appearance by abstract philosophical means—which distorts philosophy itself from its true base.

If, as we said in Part I, philosophy takes rise in *philos,* it also refers to Aphrodite in another way. For *sophia* originally means the skill of the craftsman, the carpenter (*Iliad* XV.412), the seafarer (Hesiod, *Works* 651), the sculptor (Aristotle, *Nic. Eth.* vi. 1141a).[38] Sophia originates in and refers to the aesthetic hands of Daedalus and of Hephaistos[39] who was of course conjoined with Aphrodite and so is inherent to her nature. With Aphrodite informing our philosophy, each event has its own smile on

its face and appears in a particular mode, fashion, style. Aphrodite gives an archetypal background to the philosophy of "eachness" and the capacity of the heart to find "intimacy" with each particular event in a pluralistic cosmos (Wm. James).[40]

Now, the organ which perceives these faces is the heart. The thought of the heart is physiognomic. To perceive, it must imagine. It must see shapes, forms, faces—angels, demons, creatures of every sort in things of any kind; thereby the heart's thought personifies, ensouls, and animates the world. Petrarca sees Laura:

> . . . in pathless forest shades,
> I see the face I fear, upon the bushes
> Or on an oaken trunk; or from the stream
> she rises; flashes on me from a cloud
> Or from clear sky; or issues from a rock. . . .[41]

The lines are not *to* Laura, a love lyric, but a description *of* Laura, the soul personified, the figuration in the heart by means of which aesthetic perception proceeds. It brings to life things as forms that speak.

As we saw above, it was Aristotle's psychology that laid the basis for the connection between *aisthesis* and the heart. It may be strange to hear me speak in his praise, but there are many Aristotles, and my

delight is in Aristotle the biologist who took the world of sense and shape to heart. In Aristotelian psychology, the organ of *aisthesis* is the heart; passages from all sense organs run to it; there the soul is "set on fire."[42] Its thought is innately aesthetic and sensately linked with the world.

This link between heart and the organs of sense is not simple mechanical sensationalism; it is aesthetic. That is, the activity of perception or sensation in Greek is *aisthesis* which means at root "taking in" and "breathing in"—a "gasp,"[43] that primary aesthetic response.

Translators have turned *aisthesis* into "sense-perception," a British empiricist's notion, John Locke's sensation. But Greek "sense-perception" cannot be understood without taking into account the Greek Goddess of the senses or the organ of Greek sensation, the heart, and the root in the word—that sniffing, gasping, breathing in of the world.

What is it to 'take in' or breathe in the world? First, it means aspiring and inspiring the literal presentation of things by gasping. The transfiguration of matter occurs through wonder. This aesthetic reaction which precedes intellectual wonder inspires the given beyond itself, letting each thing reveal its particular aspiration within a cosmic arrangement.

Second, 'taking in' means taking to heart, interiorizing, becoming intimate with in an Augustinian

sense. Not only *my* confession of my soul, but hearing the confession of the *anima mundi* in the speaking of things.

Third, 'taking in' means interiorizing the object into itself, into its image so that *its* imagination is activated (rather than ours), so that it shows its heart and reveals its soul, becoming personified and thereby lovable[44]—lovable not only to us and because of us, but because its loveliness increases[45] as its sense and its imagination unfold. Here begins phenomenology: in a world of ensouled phenomena. Phenomena need not be saved by grace or faith or all-embracing theory, or by scientific objectiveness or transcendental subjectivity. They are saved by the *anima mundi*, by their own souls and our simple gasping at this imaginal loveliness. The *ahh* of wonder, of recognition, or the Japanese *shee-e* through the teeth. The aesthetic response saves the phenomenon, the phenomenon which is the face of the world. "Everything shall perish except His face," says the Koran (xxxviii.88) which Corbin can understand to mean "Every thing . . . except the Face of that thing" (*CI:* 244&n; *ML:* 112–13). God, the world, everything can pass into nothingness, victims of nihilistic constructions, metaphysical doubts, despairs of every sort. What remains when all perishes is the face of things as they are. When there is nowhere to turn, turn back to the face before you,

face the world. Here is the Goddess who gives a sense to the world that is neither myth nor meaning; instead that immediate thing as image, its smile, a joy, a joy that makes 'forever.'

KALON KAGATHON AND JUNG

The decline of Aphrodite from Queen of Soul, as in Plotinus's reading of the *Symposium*, "took more than a thousand years of Christian differentiation," says Jung. He writes (*CW* 9, i: ¶60): "The anima believes in the *kalon kagathon,* the 'beautiful and the good', a primitive conception that antedates the discovery of the conflict between aesthetics and morals. . . . The paradox of this marriage of ideas [beauty and goodness] troubled the ancients as little as it does the primitives. The anima is conservative and clings in the most exasperating fashion to the ways of earlier humanity."[46]

Jung usually gives good ear to "the ancients and the primitives." It is surprising to find him siding with the Christian position. Aestheticism, Jung says, is a cult of "refined hedonism" that "lacks all moral force" (*CW* 6: ¶194); what seems a doctrine is mere anima prettiness which avoids the ugly. Again, we have the divided heart, an impenetrable wall between moral and aesthetic responses.

We need here to see more deeply into what anima is about in this marriage, for after all anima means soul and as Jung says (*CW* 9, i: ¶60), "She is not a shallow creation." We need to remember that one of the archetypal persons within the anima of beauty is Aphrodite, whose conservative, instinctual reac-

tions do not, cannot separate the aesthetic from the moral, and whose adherence to beauty rather than to ugliness requires an understanding of beauty, not in the *fin de siècle* sense of Jung's education, but in the sense of the ancient and primitive, that polytheistic world of an earlier humanity in which the doctrine first took shape.

For beauty there, then, as we have just indicated, means the form of what is presented, that which is breathed in, *aisthesis,* and by which the value of each particular thing strikes the heart, the organ of aesthetic perception, where judgments are heartfelt responses, not merely critical, mental reflections. Reflection takes on another sense than our usual one. For the thought of the heart, reflection is not bending backward (*CW* 8: ¶241), a movement afterward in time, away from the object in space as it is transformed by psychic images and judged in the mind. Rather, reflection refers to the very aesthetic quality of any event, its sheen and shape, the luster of its skin. Event itself as image. An event reflects *itself* in its *Selbstdarstellung* as an image. Aesthetic reflection is immediately given with sensation, and the aesthetic response foreshortens reflection into reflex, the spontaneous reactions of the heart's taste.

Let us go back a moment to the biography of Jung. Two passages can help us understand Jung's view on beauty. The first is merely a scene. Little boy Jung in the eighteenth-century parsonage alone in a dark

room in which was collected the art of the family. "Often I would steal into that dark, sequestered room and sit for hours in front of the pictures, gazing at all this beauty. It was the only beautiful thing I knew" (*MDR:* 16). In the moral world of the parsonage, beauty was sequestered in a dark room into which one had to sneak. Morality and beauty cut apart: little boy Jung a result of the more than thousand-years Christian differentiation.

Moreover, beauty was positioned in *art*—paintings—the literalization of *aisthesis* in art objects.

The second biographical event occurs when Jung is painting and writing his fantasies. He asks himself:

> "What am I really doing?" . . . Whereupon a voice within me said, "It is art." I was astonished. It had never entered my head that what I was writing had any connection with art. Then I thought, "Perhaps my unconscious is forming a personality that is not me, but which is insisting on coming through to expression." I knew for a certainty that the voice had come from a woman. I recognized it as the voice of a patient, a talented psychopath who had a strong transference to me. . . .
>
> Obviously what I was doing wasn't science. What then could it be but art? It was as though these were the only alternatives in the world. That is the way a woman's mind works.

> I said very emphatically to this voice that my fantasies had nothing to do with art, and I felt a great inner resistance. No voice came through, however, and I kept on writing. Then came the next assault, and again the same assertion: "That is art." This time I caught her and said, "No, it is not art! On the contrary, it is nature," and prepared myself for an argument. When nothing of the sort occurred, I reflected that the "woman within me" did not have the speech centers I had. And so I suggested that she use mine. She did so and came through with a long statement. (*MDR:* 185–86)

There are half a dozen things to note in this passage, which, let us remember, is precisely where Jung discovers "the woman within" and considers her to be soul or anima. This passage refers to the moment of the birth of "anima" in modern psychology, and anima's first statement is: Jung is doing art! Jung, however, identifies the voice with a "psychopathic patient" and attributes the opposition between art and science to "the way a woman's mind works." The opposition is his, and he is the one who resists, contradicts, and silences her; not she him. His reaction here is most unlike his close attention to Elijah and Philemon.[47]

Finally, her long statement, which presumably would sum up the anima's position on this crucial

question as to what Jung was actually doing in his black and red books, his painting and writing of imaginations, is never given in the autobiography. How different Jung's first response to anima from that of Petrarca and Dante.

Had Jung listened more receptively to that voice of the soul—examples of which I have collected in my *Healing Fiction*—Jungian psychology might have taken a different tack: less division between aesthetics and science, aesthetics and nature, art and morality, less distrust of beauty and anima—and more sense for aesthetics.

We might better have understood that the soul, that "talented psychopath" who loved Jung, was the conserver of an archaic virtue who *must* cling exasperatingly, because of resistance, to the doctrine of the beautiful and the good.

For, from the viewpoint of a psychology built from anima, what we are doing when deeply engaged in imagination is indeed aesthetic. Depth psychology *is* a depth aesthetics, and the task of psychology from that date on would have been laying out the aesthetic modes of the deep imagination, rather than the examination of images in terms of comparisons with the natural science of physics, secular anthropology, moral symbols of religion, or practical considerations of medical therapeutics.

Jung justifies his suppression of her viewpoint upon the assumption that the aesthetic and the

moral cannot be joined. He writes (*MDR:* 187): "If I had taken these fantasies . . . as art, they would have carried no more conviction than visual perceptions, as if I were watching a movie. I would have felt no moral obligation toward them." Soon afterward he gives up what he calls the aestheticizing tendency in favor of the method of understanding (*MDR:* 188; *CW* 8: ¶¶172–79).

The separation of *kallos* from *agathon* degrades Aphrodite; she falls utterly into Aphrodite Pandemos, an amoral whore of sensuality without her heavenly counterpart. Then, the world of sense has no other than a sensuous claim; an image must be *understood* to be valued, so that we are obliged to *judge* our images morally, assign them a positive or negative value in order to know how to react. We have lost the response of the heart to what is presented to the senses. We find meanings and lose responses.

Psychology is still embroiled in this dilemma so vividly presented by Jung. Aphrodite appears in psychology only to be misperceived. First, she appears in erotic transference—so powerfully that Breuer flees; and Freud translates her into the inappropriate archetypal perspective of childhood and parents. But the Gods return in our diseases, as Jung said; even in that talented psychopath was the voice[48] of Aphrodite.

She appears in Freud's hermeneutics of symbols understood by their genital shapes. She appears in

Freud's notion of libido, whose etymon refers to *lips,* sexual desire and liquid like the sap of life. Again, instead of referring libido to the *person* of the Goddess of insemination, desire, fruit, flowers, and the visible beauty of soul, it was translated into a Promethean concept of psychic energy. How different our depth psychology would have been had we let the Goddess emerge within the psychoanalytic disease.

She appears above all in the *manifest,* not as content of it (for that remains available only to understanding), but as the manifest visible image, the displayed presentation. But again, psychological theory abandoned the manifest for the hidden—even in Jung who distinguishes psychology from aesthetics in that psychology examines its material in terms of "causal antecedents," while aesthetics regards its material as "existing in and for itself" (*CW* 15: ¶135).

Approaching fantasies in terms of their causal antecedents sidesteps the impact of the image. It is deprived of its appeal, the claim of its immediate body. Something more important lurks behind—the psychodynamics by which it can be understood. The same devaluation occurs when we look at images for their symbolic contents, thereby putting in second place the form of their containment. By ignoring these formal and sensate aspects of psychic

materials, we force Aphrodite to return only via her diseases—transference; sensualism, naturalism, concretism; and the flesh as sheer superficiality.

"GOING OVER TO ANOTHER ORDER"

But what about ugliness? Surely that has been the main focus of psychotherapy. If we have neglected beauty, and the aesthetic response to the manifestation of things, we have, ever since Nietzsche, surely had a pathologizing eye, minutely scrutinizing the deformed, diseased, and horrid. Perhaps, depth psychology has indeed been aesthetic but in reverse: reversing the old pairings of the good and the beautiful by "reconstructing the gibbon,"[49] rather than Winckelmann's Apollo Belvedere.

Paradoxically it is through the ugly that psychology has come closest to the Neoplatonic vision. We have not been able to find Corbin's *himma* of the heart directly. Our theophany shows forth the Gods where they have fallen into diseases—theophany as case demonstration. The attempt of archetypal psychology to revert the diseases back to the Gods is at the same time an attempt to restore both Gods and diseases from secular ugliness. Therapy as an aesthetic undertaking requires an eye for ugliness— both delighting in and shocked by what we meet in the psyche—else we do not see the Gods at all. We see only secular human existence, case as case, demonstrating nothing beyond itself, the imagination captive in clinical anesthesia. By attempting congruities between the imagination of the in-

dividual human soul with the imaginal patterns that myths call Gods, an archetypal therapy attempts what Freud and Jung both sought: an *epistrophé* of the entire civilization to its root sources, its *archai*. This reversion begins in the pathologies where the Gods are fallen, where depth psychology has always worked with its eye attentive to the ugly.

Plotinus's definition of ugly and beautiful is immediately useful for psychology. "We possess beauty when we are true to our own being; ugliness is in going over to another order" (V.8.13). He further tells us how we can recognize going over to another order: "Let the soul fall in with the Ugly and at once it shrinks within itself, denies the thing, turns away from it, out of tune, resenting it" (I.6.2). Here is the aesthetic response. When we feel cramped, resentful, out of tune, then we have gone over to another order, and have fallen (or more likely risen, since the Fall in our reversed modern world is the hybris of ego inflation) away from the soul. This means that soul-making can become a self-steering process through aesthetic reflexes. As important as the reflective understanding of the meaning of where we are is a sensitivity to when we go over to another order. Here, the relation to ugliness guides our self-knowledge. Ugliness is the guide because aesthetic responses occur most strongly in relation with the ugly. Plotinus says: "It must be remembered that sensations of the ugly and evil impress us more violently

than those of what is agreeable . . . sickness makes
the rougher mark. . . . Illness . . . makes itself by its
very incongruity" (V.8.11).[50] Another view of psycho-
logical illness is implied here: illness results from
or is indicative of *wrong aisthesis*, and this in turn
leads to an examination of the harborers of illness,
not only in the invisibilities of psychodynamic con-
ditions and fantasies of past developments, but in
the aesthetic incongruities of persons and things
and the visibilities of the present to the senses.

Following the signals of beauty and ugliness is an
Aphroditic mode of imagining individuation. This
mode maintains Psyche always in Aphrodite's temple
all the while we go through the world making soul.
The motto that the world is the place of soul-
making, of course, comes from John Keats, and it
was Keats who also said that Beauty is Truth and who
said: "I am certain of nothing but the Heart's af-
fections and the truth of Imagination" (Letter to
Bailey, 22 November 1817).

If we can spot these signals of imagination in the
heart's affections, then we can feel when we have
gone over to another order, left ourselves, and begun
making illness. The aesthetic judgment is, as Kant
said, independent of logic. It comes spontaneously,
like a movement of the heart, even as that reaction
to ugliness: "I can't stand it. Take it away. Stop. It's
hideous, awful, dreadful. It makes me sick." This can
be a reaction to a gesture, the sight of something,

the way a person approaches, or a tone of voice. Aesthetics in everyday affairs.

The aesthetic sense perceives the form of things, apprehending the particular shape of each event, its nature disclosed by its face. These reflex reactions return psychology to that Aristotelian idea of the soul as the *form* of the body, of soul as always embodied by a form. A return to psyche as living form saves psychic phenomena from approaches defined only in terms of motion: motives, energy, dynamics. A classical idea said that Beauty arrests motion; so, too, the aesthetic response arrests those psychological theories that rely on hidden psychodynamics.

Psychology tends to forget that psyche is not only the *motion* of the body but also its *form,* so we have been forced to see the dream as running narrative (and not as image), the soul in process of growth (rather than as essence in revelation). We have lost actual form to transformation and neglected the physiognomy of what is there, the cosmos as cosmetic face.

Aesthetic reactions are responses to this face, and moral responsibility begins in these responses of disgust, delight, abhorrence, attraction—the spontaneous judgment of the heart. "Heart, instinct, principle," said Pascal. Trust *aisthesis,* the sense of the heart; otherwise we go over to another order. I can hardly stress enough the importance of this

trust, for the individual aesthetic response is also the watchdog against the Devil who slips into our lives where we least expect, dressed in the most conventional disguise. An aesthetic response is a moral response: *kalon kagathon*. Let me show you what I mean.

The novelists William Styron and George Orwell, and the social philosopher Hannah Arendt, in writing of totalitarian evil and the Nazi systematic murders in particular, have each come to the conclusion that evil is not what one expects: cruelty, moral perversion, power abuse, terror. These are its instruments or its results. But the deepest evil in the totalitarian system is precisely that which makes it work: its programmed, single-minded monotonous efficiency; bureaucratic formalism, the dulling daily service, standard, boring, letter-perfect, generalities, uniform. No thought and no responsiveness. Eichmann. Form without anima becomes formalism, conformism, formalities, formulas, office forms—forms without luster, without the presence of body. Letters without words, corporate bodies without names. All the while beauty is sequestered into the ghetto of beautiful things: museums, the ministry of culture, classical music, the dark room in the parsonage—Aphrodite imprisoned.

The "general" and the "uniform" happen in thought before they happen in the street. They happen in thought when we lose touch with our aes-

thetic reflexes, the heart no longer touched. The aesthetic reflex is indeed not merely disinterested aestheticism; it is our survival. So, when we are dulled, bored, an-esthetized, these emotions of bleakness are the reactions of the heart to the anesthetic life in our civilization, events without gasping—mere banality. The ugly now is whatever we no longer notice, the simply boring, for this kills the heart. Our recourse is to Aphrodite, and our first way of discovering her is in the disease of her absence.

THE LION ROARS AT THE ENRAGING DESERT

So, the question of evil, like the question of ugliness, refers primarily to the anesthetized heart, the heart that has no reaction to what it faces, thereby turning the variegated sensuous face of the world into monotony, sameness, oneness. The desert of modernity.

Surprisingly, this desert is not heartless, because the desert is where the lion lives. There is a long-standing association of desert and lion in the same image, so that if we wish to find the responsive heart again we must go where it seems to be least present, into the desert.

According to *Physiologus* (the traditional lore of animal psychology), the lion's cubs are stillborn. They must be awakened into life by a roar. That is why the lion has such a roar: to awaken the young lions asleep, as they sleep in our hearts. Evidently, the thought of the heart is not simply given, a native spontaneous reaction, always ready and always there. Rather, the heart must be provoked, called forth, which is precisely Marsilio Ficino's[51] etymology of beauty; *kallos*, he says, comes from *kaleo*, provoke. "The beautiful fathers the good" (Plato, *Hipp. Maj.* 297b). Beauty must be raged, or outraged into life, for the lion's cubs are stillborn, like our lazy political compliance, our meat-eating stupor before the

television set, the paralysis for which the lion's own metal, gold,[52] was the paracelsian *pharmakon*. What is passive, immobile, asleep in the heart creates a desert which can only be cured by its own parenting principle that shows its awakening care by roaring. "The lion roars at the enraging desert," wrote Wallace Stevens. "Heart, instinct, principle," again Pascal.

Alongside the lion lives the desert saint. St. Paul the first hermit, St. Mary of Egypt, Euphemia, Onuphrius—each a Saint with a lion.[53] What is the relation of Saint and Lion? Is it an equation? Lion as Saint, Saint as Lion: Mark as exemplar. Does this then imply that to find the statistical saintly bit of oneself, one needs first to find the lion, the lion who lives in the heart and roars in sulphuric passion at the enraging desert?

Pelagius tells the tale of a pious anchorite who went into the desert to talk of the "wingy mysteries of divinity" with one older and wiser than he, but that old man of the desert turned away from his questions. When asked why he had refused to enter into talk, the old man said: "If he had spoken to me of the passions of the soul I could have answered him: but of the things of the spirit I am ignorant." (The old man wanted to talk of the lion, not of wingy mysteries.) The pious anchorite hearing of this had heart-searchings and came back to the old man and said, "What shall I do, my father, for the passions

of the soul have dominion over me?" And the two talked a long while; then the anchorite was able to say: "Verily, this is love's road."[54] The more our desert the more we must rage, which rage is love.

The passions of the soul make the desert habitable. One inhabits, not a cave of rock, but the heart within the lion. The desert is not in Egypt; it is anywhere once we desert the heart. The Saints are not dead; they live in the leonine passions of the soul, in the tempting images, the sulphuric fantasies and mirages: love's road. Our way through the desert of life or any moment in life is the awakening to it as a desert, the awakening of the beast, that vigil of desire, its greedy paw, hot and sleepless as the sun, fulminating as sulphur, setting the soul on fire. Like cures like: the desert beast is our guardian in the desert of modern bureaucracy, ugly urbanism, academic trivialities, professional official soullessness, the desert of our ignoble condition.

The heart of Harvey, already dead, "fitness" replacing vitality, creates the desolation it jogs through, mufflers over the ears, blinded in the sweat of extending its life-expectancy, zombies creating the desert by running and running with nowhere to go. If beauty arrests motion, motion eradicates beauty. And the heart of Augustine fails to extend beyond the *intima mea, culpa mea.* Work it out alone or secular sharing in group confession. Subjectivisms without rage.

We fear that rage. We dare not roar. With Auschwitz behind us and the bomb over the horizon, we let the little lions sleep in front of the television, the heart, stuffed full of its own coagulated sulphur, now become a beast in a lair readying its attack, the infarct.

Psychologically, we subdue our rage with negative euphemistic concepts: aggression, hostility, power-complex, terrorism, ambition, the problem of violence. Psychology analyzes the lion. Perhaps Konrad Lorenz is wrong, and the counselors wrong too, who seek to find a way beyond aggression. Is it 'aggression,' or is it the lion roaring at the enraging desert? Has psychology not missed the native sulphur, neglected Mars who rides a lion, Mars, beloved of Aphrodite, demanding right. *Splendor Solis. Sol invictus:* Mithra of the heart.

Earlier we spoke of prayer. We said it was a necessary consequent to confession because it moves the heart from 'self' preoccupation into witnessing the independent power of images. In all of Plato there is only one prayer. It comes at the very end of the *Phaedrus,* that dialogue concerning beauty to which we have already referred. And it is a prayer of moral restraint. Socrates offers his prayer to Pan, and what he offers is his desire to become "fair within," "grant me beauty in the inward soul" and "as for gold, and outward things, may they not war against the spirit within me."

The curious, important fact here is that Socrates relates this beauty and restraint with Pan the Goat-God. The prayer is to the hairy-legged, animal-tailed figure unique among the major Greek divinities for his bestial shape. Socrates' prayer for beauty and limitation is to the animal-God. Could this mean that confession, too, is to the animal? Then, we go over to the other order each time we desert the animal, that saintly lion or leonine saint, who keeps us fair within and limits our reach. The heart as lion is truly king of beasts, a bestial King, and our inner beauty—our dignity, nobility, proportion, our portion of lordliness—comes, as lore of character has always assumed, from the animal of the heart.

THE WHITE SULPHUR AND
THE ILLUSIONS OF THE HEART

If we conclude here we end in either Mithraic, martial militancy or in blind indignation, the alchemical lion eating the sun,[55] consciousness devoured in its own outrage. The moral restraint that is inherent to the animal, its natural piety, requires in us human beings an operation on the heart. Gods appear as animals and so the natural animal is already divine; whereas the animal that has been humanized has lost its creaturely divinity. Our lion rages and our sulphur burns. Our saint is eaten by lions. We cannot let loose our aesthetic outrage in its simple form. Alchemical psychology recognized this need for work on the lion.

Alchemical psychology considered the black and red sulphurs, and the green lion, in desperate need of subliming.[56] One well-known method cuts off the green lion's paws, depriving it of its reach into the world. Yet it stays alive as a *succus vitae* in the heart, for "green is the color of the heart and of the vitality of the heart," as we know from Corbin.[57] The color of the *himma* must be green like the natural driving sulphur that is also the green/red copper Goddess Venus.[58] This ardent green has to be enlightened, the sulphur chastened: a whitening of the heart.

To make white the heart is an *opus contra naturam*.

We expect the heart to be red as its natural blood, green as its hopeful desire. This heart operation originates in the dilemma presented by sulphur in Part I: the imagination captive in its sulphur that both burns and coagulates at the same instant, imagination held fused into its desire and its desire fused with its object. The *himma* blinded, unable to distinguish between feeling and image, image and object, object and subject, true imagining and illusion.

Alchemy often speaks of subliming to a sulphur white as snow. This is not only an operation of calming and cooling, the "Doves of Diana."[59] In fact sublimation requires going with the fire, like curing like, raising the temperature to a white heat so as to destroy all coagulations in the intensity of the desire, so that *what* one desires no longer matters, even as it matters most, mattering now sublimed, translucent, all flame.

The heart is more often whitened by its own weakening. Failures of the heart. Cowardice, nostalgia, sentimentalism, aestheticizing, doubt, vanity, withdrawal, trepidation—these emotions too arise from the heart. These are the heart's own anima states, a whitening within its own principle. Each thing must be cooked in its own blood, says alchemy. So, the red heart whitens within its own failures.

Sometimes an aesthetic reflex starts the whitening on its way: a shiver, a swoon, a need for loveli-

ness, wanting grace more than greed, and honor as the final satisfaction—these can be indications of the lion's taming with virgin's milk. Whitening flows over the raging lion, as Aphrodite shields her warrior son, Aeneas, flowing over him, as Homer says, with her white arms and white robe (*Iliad* V.312–15); as she herself is touched to the heart, wounded, weak, and retreats; as she withdraws her favorites from direct battle.[60]

Aphrodite whitens in other ways too: she sophisticates[61] by bringing the intelligence of wiles, deceits, persuasions, teaching the arts of intimacy and subjectivity.[62] Subjective intimacy was theologized by Augustine and became confessional; whereas the poetry of Sappho reveals Aphrodite as the archetypal person who sensitizes one to an intimacy that need not be confessional. The strident confessional subjectivity of much contemporary Sapphic poetry misses the Aphroditic touch, that sense of the sensuous beyond subjective sensation.

When the sulphur whitens within the heart, we feel at first discouraged, shrinking, in vain, nostalgic—a white longing rather than a red need—and subjectively weakened. The heart now discovers its own inhibition and, driven in on itself, it feels both its desire and its inability, passion without seizure, compulsion and impotence together, "I want" and "I can't" at once. The whitened sulphur brings to consciousness the *cor duplex*,[63] the wall down the

middle of our hearts which Harvey demonstrated, splitting apart that simple fantasy of untamed sulphur that the heart is whole and the heart is one.

The wall down the middle of our hearts necessitates the complex circulation of the heart's contents—its imagination and its responses—to the periphery of our beings, making us all heart, heart all through us, as Avicenna's physiology said a thousand years ago.[64] This bifurcated and dislocated heart results from these operations of whitening, so that the heart may no longer be only the literal organ and the literal outrage of the royal monistic lion. Now its thought moves widely around, always in motion as reactions and aesthetic responses. There is a circulation of the light in the circulation of the blood,[65] thinking in the skin and in the feet, in the throat and temple pulses; the "least pulses of my body shook," as Dante said on seeing Beatrice. This heart acts not as central king or pump, but as the circulation itself, sensitive to many things in many places, its red passion whitened to compassion.

Besides the weakening, sophistication, and circulation, the heart whitens in yet another way: through its own illusions. Any explication of the heart's thought must also account for the heart's illusions: that we fall wrongly in love, delight in bad tastes, follow a false flag, father a betrayer, stand loyal to hollow codes, braggadocio, kitsch. These too are

signs of the lion. What heart does not go "over to the other side," deluded by its leonine conviction, especially that most heartfelt delusion: its faith in its feelings as its own truth.

The illusions of the heart must be grounded in the same place as its truths. Those condemnations of the heart which reach back to the dawn of philosophy have always blamed it for opinion, subjectivism, illusion, and clinging to the world of untrustworthy sense. Yes, why not? Imagination begins in a heart aware that there is both true and false imagining and that these are not contradictories, but rather co-relatives, even co-terminous. We cannot have the true without the false. We recognize true imagining by means of a subtle sense of illusions, a sensitivity to going off wrong. The sophistication of the heart is its double-beat, an echoing syncopation; or its interior wall, a two-sided mirror by means of which reflective speculations may be taken to heart and imagined further. Only this interior reverberation allows the heart to witness the images in its feelings rather than to be identified with its feelings in that subjectivism which is the ground of all false imagining. Remember, *himma* presents the images of the heart as essentially, though intimately,[66] real; yet the reality of its persons is independent of my person.

Thus we can affirm the heart's illusions as necessary for the sophistication of its imaginings. It will

be aware that its realities are not real and its ir-
realities are real, that its feelings are its truth and
yet these feelings are fantasies of its desire and auras
of its images, that as it loves it lies to further invent
its love, and that the sensate sulphuric world with
which it burns is so compelling because of our
heart-hunger for forms, for beauty, which that sen-
sate world embodies. The heart would be touched,
asks that the world touch it with tastes and sounds
and smells; *aisthesis;* touched by the image.

I have tried in this essay to restore the animal sense
to imagining by remembering the lion in the heart
before Harvey, before Augustine. This heart awakens
in the aesthetic response. It is an animal awareness
to the face of things. I have also tried to connect this
animal awareness with the *himma,* suggesting that it
is by means of the lion in the heart that we perceive
and respond imaginally. As Corbin has written: ". . .
certain of our traditions . . . mention that animals
see things which, among human beings, can be seen
only by visionary mystics. It is possible that this
animal vision takes place in the absolute *mundus
archetypus. . ."* (*SB:* 146).

This thought of the heart returns us to an animal
thought, intimacy released from confession into im-
mediacy, the courage of immediate intimacy, and not

merely with ourselves, but with the particular faces of the sensate world with which our heart is in rapport like a watching animal in its lair, a guardian angel of survival who knows each time we go over to the other side.

For us each to become "fair within" we need to let this lion bring its decorum into our behavior. In the blood of the animal is an archetypal mind, a mindfulness, a carefulness in regard to each particular thing. And this minding of events arises in the reactions of the heart, neither as mere personal feelings nor as a mechanical mindlessness of the Harveyein heart that does not consider, does not conceive. With the lion lives the saint, by which I mean that sense of restraint incumbent upon being perceived by the animated world in which is the presence of Aphrodite with whom the saint always contends. To be is to be perceived[67]—by her, by them. It is not merely *our* aesthetic reactions, but *theirs* to us. Not the subject an observer as in a scientific universe, all things turning around one subject, but the subject, ourselves, subjected to the gaze of things, ourselves a display. To the ensouled world we too are objects of *aisthesis,* aesthetically breathed in by the *anima mundi,* perceived by her, perhaps, even, aesthetically breathed out as images by an ardent *himma* in the heart of each thing.

1. The works of Henry Corbin quoted in the text are: *Creative Imagination in the Sufism of Ibn 'Arabi,* Bollingen Series (Princeton: Princeton Univ. Press, 1969) (French, Paris: Flammarion, 1958) = *CI; Spiritual Body and Celestial Earth,* Bollingen Series (Princeton: Princeton Univ. Press, 1977) (French, Paris: Buchet-Chastel, 1960) = *SB; The Man of Light in Iranian Sufism* (Boulder and London: Shambhala, 1978) = *ML.*

2. Cf. below, p. 45 on "sophia," the other half of the word "philosophy."

3. I have subjoined to the heart of the lion the heart as locus of the *sensus communis,* the place of natural law connecting all individuals with each other and with the order of the world. How *sensus communis* perceives this order is discussed below in Part II. The various implications of the *sensus communis,* although important to heart theory, cannot find enough place in this paper. Cf. H.-G. Gadamer, *Truth and Method* (N.Y.: Seabury Press, 1975), pp. 19–39.

4. D. H. Lawrence, *Fantasia of the Unconscious* (London: Heinemann, Phoenix, 1961), p. 33.

5. Ph. Wolff, *Die Gekrönten* (Stuttgart: Klett, 1958), p. 182, notes that the heraldic lion always is *single.* Only one lion, like only one King.

6. Cf. *CW* 14: ¶¶134–53 for an excellent digest of alchemical passages on sulphur. Jung notes its connection with Venus (¶139), and Titus Burckhardt (*Alchemy* [London: Stuart and Watkins, 1967], p. 140) notes its connection

with *anima* or cosmic vitality of the universe experienced as the heat of the heart. In sulphur's "compulsion" and "lack of freedom" (Jung, ¶¶151–52) resides, I suggest, the problem of the captive imagination (in Corbin's sense), necessitating those operations on the heart (whitening the sulphur) which are discussed below in Part II.

The works of Jung quoted are *The Collected Works of C. G. Jung*, Bollingen Series (Princeton: Princeton Univ. Press and London: Routledge & Kegan Paul) = *CW; Memories, Dreams, Reflections*, recorded and edited by Aniela Jaffé (N.Y.: Vintage Books, 1961) = *MDR*.

7. John Read, *Through Alchemy to Chemistry* (London: Bell, 1957), p. 18.

8. "New Chemical Light" in *Hermetic Museum* (London: Stuart and Watkins, 1953), II: 154.

9. Cf. Paracelsus, *The Hermetic and Alchemical Writings*, trans. A. E. Waite (N.Y.: University Books, 1967), I: 127. For some of these other attributes of sulphur—"fatness of the earth," its "very strong action," "fiery nature," "gum," and "entirely smoky," see *Libellus de Alchimia* (ascribed to Albertus Magnus), trans. Virginia Heines (Berkeley: University of California Press, 1958), p. 22.

10. I borrow this thought from Wolfgang Giegerich, "Der Sprung nach dem Wurf—Über das Einholen der Projektion und den Ursprung der Psychologie," *Gorgo I* (1979): 49–71.

11. Sulphur, according to Paracelsus (I: 245) "gives body, substance, and build" to the imagination of alchemy. The

"body which is appropriate to each it takes from sulphur." "Body" of course has many meanings depending on the alchemist and the context of operation, but here I take body to mean *soma* as in ancient Greek usage, like what we would now call "physical person" (cf. Hirzel, note 27 below).

12. *CW* 14: ¶151.

13. Sulphur is responsible for "The Tastes and Odours of Metals" in Albertus Magnus, *Book of Minerals,* trans. Dorothy Wyckoff (Oxford: Clarendon, 1967), pp. 194–95.

14. Cf. Allen G. Debus, *The English Paracelsians* (London: Oldbourne, 1965), pp. 113–16 on Fludd's sun as the "heart of heaven" and the heart as the sun of the body, connected by 'air' and in circulation both in the macrocosm and the microcosm of the blood.

15. "Perpetuum sanguinis motum in circulo fieri pulsu cordis." Cf. Ch. Singer, *The Discovery of the Circulation of the Blood* (London: Dawson, 1956).

16. Felix Boenheim, *Von Huang-ti bis Harvey* (Jena: Fischer Verlag, 1957); T. Doby, *Discoverers of Blood Circulation* (N.Y.: Aberlard-Schuman, 1963).

17. Ibid. The "thought of the heart" can be expressed in more ideographic languages such as Chinese *Hsin-li* as heart-reason; Hebrew *leb* as heart-imagination or intelligence; and Egyptian *ab* which means "interior, sense, intelligence, understanding, attention, intention, manner, will, wish, desire, mind, courage, lust, and self"

[compare Greek *enthymesis*], according to E.A. Wallis
Budge, *An Egyptian Hieroglyphic Dictionary* (N.Y.: Dover,
1978), I: 37b. Unlike other principal organs, the heart was
not eviscerated in the preparation of the Egyptian
mummy for the underworld, but was left in the cadaver.

18. The Bruno and Shakespeare examples are also quoted
 by F. Marti-Ibanez, "Padua and London: A Harveian Tale
 of Two Cities," in *Centaur* (N.Y.: M. D. Publ., 1958).

19. The word "heart" appears in thirty-nine lines in *Cor-
 iolanus,* more frequently than in *Othello, Hamlet, Julius
 Caesar, Romeo and Juliet,* or *Henry V*—though not more
 often than in *King Lear, Richard II,* or *Antony and Cleopatra.*

20. Singer, *The Discovery of the Circulation of the Blood,* p. 66.

21. Ibid., p. 46.

22. "It is important to remember that there is no communi-
 cation between . . . one side of the heart and the . . .
 other side of the heart, except through the blood vessels
 and capillaries. [Capillaries were discovered by Malpighi
 only after Harvey's work.] The existence of a more direct
 means of communication was firmly believed until the
 seventeenth century. . . . The removal of this belief was
 one of the most important events in the history of
 science." Ibid., p. 6. Harvey demonstrated the wall down
 the middle in a late experiment on—N. B.—the corpse of
 a hanged highwayman and described it in a letter to a
 colleague. Doby, *Discoverers of Blood Circulation,* pp. 219–20.

23. See below, note 64.

24. Dietrich von Hildebrand, *The Sacred Heart* (Baltimore: Helicon, 1965).

25. Paul Henry, *Saint Augustine on Personality* (N.Y.: Macmillan, 1960), p. v.

26. From von Hildebrand, *The Sacred Heart*.

27. Cf. Rudolf Hirzel, *Die Person, Begriff und Name derselben im Altertum* (Munich: Königlich Bayerische Akademie der Wissenschaft, 1914).

28. Cf. Robert Meagher, *An Introduction to Augustine* (N.Y.: Harper & Row, 1978), ch. "Person," rich with passages from Augustine that link confession of feeling with personhood. Also, A. Maxsein, *"Philosophia cordis* bei Augustinus," in *Augustinus Magister,* Études Augustiniennes Suppl. (Congrès Internat. Augustinien, Sept. 1954, n.d.), I: 357–71.

29. The shadings of difference are exposed by A. Guillaumont, "Les sens des noms du coeur dans l'antiquité," *Le Coeur,* Études Carmélitaines (Bruges: Desclée de Brouwer, 1950), pp. 41–81.

30. Examples of recitals fill Corbin's works; see especially his *Avicenna and the Visionary Recital,* 2d ed. (Spring Publ., 1980), and *L'archange empourpré* (Paris: Fayard, 1976).

31. Coleridge, who invented the term "self-realization," saw that this self of personality becomes only self-seeking subjectivism unless its ground is 'outside' itself in a 'person' that is not the human person and to whom prayer

is addressed. (A.J. Harding, *Coleridge and the Idea of Love* [Cambridge: Cambridge Univ. Press, 1974], p. 143; L. S. Lockridge, *Coleridge the Moralist* [Ithaca: Cornell Univ. Press], pp. 124–26.) His own immense problems with prayer and with his creative imagination perhaps are linked because he did not accept the intercessory figures which are so essential to the notion of prayer in Corbin as a dialogical encounter with such figures. Coleridge could never release prayer from moral duty to a single high God into prayer as imagination. (Cf. Lockridge, pp. 102–09; J. R. Barth, *Coleridge and Christian Doctrine* [Cambridge, MA.: Harvard Univ. Press, 1969], pp. 181–85.)

32. Examples of such talks in active imagination were presented in detail at Eranos 1977 in my paper "Psychotherapy's Inferiority Complex" and subsequently published in *Healing Fiction* (Barrytown, N.Y.: Station Hill Press, 1983).

33. Cf. Jung, *CW* 7: ¶167.

34. Cf. Apuleius, *The Golden Ass* VI.28, where Psyche's beauty is essential to her nature and immediately visible to all people in the street, the very trait that made Venus envious.

35. Cf. E. Neumann, *Amor and Psyche* (N.Y.: Pantheon, 1956); J. Hillman, *The Myth of Analysis* (N.Y.: Harper & Row, 1978); M.-L. von Franz, *A Psychological Interpretation of the Golden Ass of Apuleius* (Dallas: Spring Publ., 1980); A. B. Ulanov, *The Feminine in Jungian Psychology and Christian Theology* (Evanston: Northwestern Univ. Press, 1971).

36. Paul Friedrich, *The Meaning of Aphrodite* (Chicago: Univ.
 of Chicago Press, 1978), pp. 202–04. "Through Aphrodite
 the whole world becomes pellucid and thus so brilliant
 and smiling. . .": K. Kerényi, *Goddesses of Sun and Moon*
 (Spring Publ., 1979), p. 58. Compare *SB:* 213: "The power
 of imagination is without doubt consubstantial with the
 soul. . . . In fact, with respect to the soul, the Imagina-
 tion is like the Soul of the Heaven of Venus." Both the
 sensible nature of imagination—that it is not merely ab-
 stract phantasms in the mind—and the imaginal, pellu-
 cid nature of sensation—that the world is not merely
 dense, concrete, and unsmiling—we owe to Aphrodite.

37. As Walter F. Otto (*The Homeric Gods* [N.Y.: Pantheon, 1954],
 p. 101) points out, Aphrodite is not the desire of Eros
 proceeding "from the desiring subject, but from the
 beloved object. Aphrodite is not the loving one: she is
 beauty and smiling charm; she enraptures. Not the urge
 to take possession comes first, but rather the magic of
 an appearance that draws irresistibly. . . ."

38. Aristotle recognizes the first meaning of *sophia,* referring
 to the *sophia* (skill in art) of Phidias and Polyclitus; but
 then he goes on to separate the term from its aesthetic
 base and give it the abstract sense of "knowledge of
 highest objects" and "truth about the first principles."
 Once *sophia* has been divided from aesthetic skill, the
 handcraft aspect returns as secondary in the very next
 paragraphs, e.g., *phronesis* or practical wisdom. This split
 between wisdom and practical action still detrimentally
 determines all later Aristotelian-influenced metaphysics,
 whereas *sophia* originally implies that thought and ac-
 tion lie together in any single move of the aesthetic hand.

39. Cf. Xenophon, *Memorabilia* 4.2.33; Plato, *Protagoras* 321d.

40. In his *A Pluralistic Universe* (Hibbert Lectures, 1909), William James argues for a radical pluralism of "eachness" against all varieties of rational and abstract monism. Essential to his argument is the experience of "intimacy" which he claims is only possible within a pluralistic universe. See his Chapters I and VIII, especially.

41. E. H. Wilkins, *The Life of Petrarch* (Chicago: Univ. of Chicago Press, 1963), p. 20 (from *Metricae,* I.6).

42. As discussed by Charles Lefevre in *Aristotle on the Mind and the Senses,* ed. G. E. R. Lloyd and G. E. L. Owen (Cambridge: Cambridge Univ. Press, 1978), pp. 44–45.

43. R. B. Onians, *The Origins of European Thought* (Cambridge: Cambridge Univ. Press, 1954), pp. 74–75. Onians notes parallels with Hindu thought that speaks of the senses as breaths. Other parallels, deriving perhaps from Aristotle, occur in Avicenna [Ibn Sina] (O. C. Gruner, *The Canon of Medicine of Avicenna* [London: Luzac, 1930], p. 124): "The foundation or beginning of all these [soul] faculties is traceable to the heart," where "heart" means "a storehouse of the breath" (p. 123) which itself is "a luminous substance . . . a ray of light" (p. 535).

44. On the relation of personification and loveableness, see my *Re-Visioning Psychology* (N.Y.: Harper & Row, 1975), pp. 14–16.

45. John Keats, *Endymion* (opening lines): "A thing of beauty

is a joy forever:/Its loveliness increases; it will never/Pass into nothingness. . . ."

46. The locus classicus of *kalon kagathon* is presented as a negative question in the *Hippias Major* 297c: ". . . should we be willing to say that the beautiful is not good, nor the good beautiful? Most certainly not."

47. *Healing Fiction,* Part Three, and also Part Two, where I discuss Jung's relation to these imaginal figures; Jung was however "distinctly suspicious" of Salome (*MDR:* 181), whom he met with Elijah and Philemon.

48. Ficino (*Commentary on Plato's Symposium* V.2) directly connects beauty with the voice.

49. I am referring here to the paradigmatic figures of the individuation process in Jung's *Psychology and Alchemy* (*CW* 12: ¶¶164–65, 169, 175, 181) in which the "important place in the centre is reserved for the gibbon about to be reconstructed."

50. Compare Plotinus on the psychological power of ugliness with the relevant passages quoted from Frances Yates (*The Art of Memory*) in my *The Myth of Analysis,* pp. 197–98, with discussion.

51. Ficino, *Commentary on Plato's Symposium* V.2.

52. E. C. Whitmont, "Nature, Symbol, and Imaginal Reality," *Spring 1971:* 72, describes a psychosomatic syndrome which symbolizes with ("proves") metallic gold: "varying degrees of depression, irritability, brooding, listlessness,

hopelessness . . . headaches, a rise of blood pressure and a disturbance of the heart function." As these patients are ill from gold, so "they are most responsive to therapeutic gold."

53. According to Jean Servier, North African Muslim Saints have been seen by pilgrims as lions and have been heard to roar. Alphonse Daudet in his *Tartarin de Tarascon* made his hero ridiculous because, in hunting a lion, he killed a domesticated one which the Brothers of Kadriya (the most popular brotherhood in North Africa) had with them when asking for alms.

54. Helen Waddell, *The Desert Fathers* (London: Constable, 1936), pp. 28–29.

55. *CW* 12: fig. 169.

56. Philalethes, *Secrets Reveal'd,* writes of the "Green Lion . . . killing all things with his Poyson" (quoted by B. J. T. Dobbs, *The Foundations of Newton's Alchemy or 'The Hunting of the Greene Lion'* [Cambridge: Cambridge Univ. Press, 1975], p. 68).

57. H. Corbin, *ML:* 77–78. Further on green as color of the soul, see Corbin, "Realisme et symbolisme des couleurs en cosmologie Shi'ite," *Eranos Jahrbuch 41—1972,* pp. 141, 152.

58. On Venus as green, see *CW* 13, p. 226n, where the attributes of Venus are bride, sister, air, green, green lion; and Benedictus Figulus, *A Golden Casket of Nature's Marvels* (London: Stuart and Watkins, 1963), p. 282, who warns

against those "who accept Venus as sulphur," implying the illusion in assuming the *sal veneris* or green lion (= Venus) to be the whole and true nature of sulphur. The green lion and the color green cannot be identified with any single one mineral or planet, but refer to the desirability of the world which appears as sulphur, as lion, as Venus, etc. This 'darkened' smoky green requires the illumination of the *visio smaragdina* of which Corbin writes in his *Man of Light,* an enlightening that results from an alchemical operation so that the heart's *himma* can reflect the sense world as images of imaginal realities.

59. Cf. Newton in Dobbs, *Foundations of Newton's Alchemy,* pp. 171, 181.

60. Cf. Friedrich, *The Meaning of Aphrodite,* p. 93.

61. Ibid., p. 123.

62. Ibid., for an excellent discussion of subjectivity and Sapphic poetry.

63. The *dipsychos,* or double-hearted, is a rare term of moral opprobrium in the Bible meaning simulation, even lying. (Cf. *Le Coeur,* p. 67.) By upholding the simplicity of the heart, the Church tradition makes either simplistic or abysmal the complexity of the heart's capacity for deception which this section of my paper is trying to differentiate.

64. "The heart to anatomy is a circumscribed organ; to Avicenna it is part of a force occupying the whole body." Gruner, *The Canon of Medicine of Avicenna,* p. 12. The

The Thought of the Heart

"whole body" can be understood as the "volume" (*jism*), i.e., the fullest amplification of the heart (cf. *SB:* 180f.).

65. By light in the blood I refer to the circulation of consciousness throughout all senses which has its parallels in the circulation of the light (*CW* 13: ¶¶27–82), and even more in the "rose-coloured blood" in alchemy (¶¶383–91, 433), where the blood red lightens to rose red indicating, among other things, the heightened sensitization of the five senses: "Praise me in my five senses, which are indicated by this rose" (¶388). Of course, the flower, rose, in antiquity belonged to Isis, Aphrodite, Venus, Dionysus, the Muses, and Graces (Barbara Seward, *The Symbolic Rose* [N.Y.: Columbia Univ. Press, 1960], pp. 1–17; reprinted: Dallas: Spring Publ., 1989). Gertrude Stein expressed the circulation of the rose in her paradigmatic sentence, "a rose is a rose is a rose." Again, we must not miss that it is particularly the most sulphuric and 'animalistic' sense of smell that correlates with the rose-colored blood, for the text which Jung quotes (¶388) goes on to say: "through the sense of smell he [Christ] has always a certain loving affection directed towards man." I have expanded on smell in both *The Dream and the Underworld* (N.Y.: Harper & Row), pp. 185–88, and in my "Image-Sense," *Spring 1979:* 139–43.

66. The "intimate taste" (*dhawq*) of imagining (*CI:* 221–22) depends on the *himma*. Combining this notion of intimacy with that of Wm. James (note 40), it seems we can become intimate with an image or a thing in a sensuous way only when we have abandoned the rational account of it. Intimacy, whether in Sappho, Corbin, or James, depends on the experience of the particular as such; this

87

gives us a new way of understanding Aristotle's phrase "It would seem that experience of particular things is a sort of courage" (*Nic. Eth.* 3.11.1116b).

67. "*Esse* is *percipi*" from George Berkeley was the motto of my Eranos lecture in 1976, where its psychological significance is discussed further (*Eranos Jahrbuch 45–1976* [Leiden: E. J. Brill, 1980], pp. 221–79; reprinted as *Egalitarian Typologies versus the Perception of the Unique* [Dallas: Spring Publ.]).

ANIMA MUNDI:
THE RETURN OF THE SOUL
TO THE WORLD

Maior autem animae pars extra corpus
est (The greater part of the soul is out-
side the body).

Sendivogius

PSYCHIC REALITY ·

To speak, to ask to have audience today in the world, requires that we speak to the world, for the world is in the audience; it too is listening to what we say. So these words are addressed to the world, its problems, its suffering in soul. For I speak as a psychologist, a son of soul, speaking to psyche.

To say "son of soul" is to speak in a Renaissance, Florentine mode, following Marsilio Ficino who was the first to place the soul in the center of his vision, a vision which excludes nothing of the world's affairs because the psyche includes the world—all things offer soul. Each and every thing of our constructed urban life has psychological import.

The renaissance of a psychology that returns psychic reality to the world will find its starting point in psychopathology, in the actualities of the psyche's own suffering where depth psychology always arises, rather than in any psychological concepts about that

reality. The discrepancy between actual psychic re-
ality and psychology's conceptions shows nowhere
better than in psychology itself which today is more
exhausted than the patients who turn to it. Depth
psychology seeks its own renaissance. It has become
self-enclosed, pretentious, commercial, permeated
with the *mauvaise foi* of disguised power, not reflect-
ing Ficino's sense of soul but insidiously adapting
to a world that has increasingly ignored that soul.
Yet psychology reflects the world it works in; this
implies that the return of soul to psychology, the
renaissance of its depth, calls for a return of psychic
depths to the world.

I find today that patients are more sensitive than
the worlds they live in. Rather than patients not be-
ing able to perceive and adapt 'realistically,' it is the
reality of the world's phenomena that seems unable
to adapt to the sensitivity of the patients. I am as-
tounded by the life and beauty in the patients vis-
à-vis the dead and ugly world they inhabit. The
heightened awareness of subjective realities, that
soul sophistication resulting from one hundred
years of psychoanalysis, has become incommen-
surable with the retarded state of external reality,
which moved during the same one hundred years
toward brutal uniformity and degradation of quality.

When I say that the patients' complaints are real,
I mean realistic, corresponding with the external
world. I mean that the distortions of communica-

tion, the sense of harassment and alienation, the deprivation of intimacy with the immediate environment, the feelings of false values and inner worthlessness experienced relentlessly in the world of our common habitation are genuine realistic appraisals and not merely apperceptions of our intra-subjective selves. My practice tells me I can no longer distinguish clearly between neurosis of self and neurosis of world, psychopathology of self and psychopathology of world. Moreover, it tells me that to place neurosis and psychopathology solely in personal reality is a delusional repression of what is actually, realistically, being experienced. This further implies that my theories of neurosis and categories of psychopathology must be radically extended if they are not to foster the very pathologies which my job is to ameliorate.

Not so long ago the patient's complaint was inside the patient. A psychological problem was considered to be *intra*-subjective; therapy consisted in readjusting inner psychodynamics. Complexes, functions, structures, memories, emotions—the interior person needed realigning, releasing, developing. Then, more recently, owing to group and family therapies, the patient's complaint was located in the patient's social relations. A psychological problem was considered to be *inter*-subjective; therapy consisted in readjusting inter-personal psychodynamics within relationships, between partners, among mem-

bers of families. In both modes, intra- and inter-, psychic reality was confined to the subjective. In both modes the world remained external, material, and dead, merely a backdrop in and around which subjectivity appeared. The world was therefore not the province of therapeutic focus. Therapists who did focus there were of a lower, more superficial order: social workers, counselors, advisors. The deep work was inside the person's subjectivity.

Of course social psychiatry, whether behaviorist, Marxist, or more broadly conceived, strongly emphasizes external realities and locates the origins of psychopathology in objective determinants. The 'out there' largely determines the 'in here,' according to this view. This was especially the American dream, an immigrant's dream: change the world and you change the subject. However, these societal determinants remain external conditions, economic, cultural, or social; they are not themselves psychic or subjective. The external may cause suffering but it does not itself suffer. For all its concern with the outer world, social psychiatry too works within the idea of the external world passed to us by Aquinas, Descartes, Locke, and Kant.

Precisely this external, non-subjective view of the world now needs to be reworked.

Before we can proceed with it, we have first to recollect the idea of reality which generally operates throughout depth psychology. Psychological dic-

tionaries and schools of all orientations agree that reality is of two kinds. First, the word means the totality of existing material objects or the sum of conditions of the external world. Reality is public, objective, social, and usually physical. Second, there is a psychic reality, not extended in space, the realm of private experience that is interior, wishful, imaginational. Having divided psychic reality from hard or external reality, psychology elaborates various theories to connect the two orders together, since the division is worrisome indeed. It means that psychic reality is conceived to be neither public, objective, nor physical, while external reality, the sum of existing material objects and conditions, is conceived to be utterly devoid of soul. As the soul is without world, so the world is without soul.

Therefore when something goes wrong in a life, depth psychology still looks to intra- and inter-subjectivity for the cause and the therapy. The public, objective, physical world of things—buildings and bureaucratic forms, mattresses and roadsigns, milk-packages and busses—is by definition excluded from psychological etiology and therapy. Things lie outside the soul.

Psychotherapy has been working successfully within its province of psychic reality conceived as subjectivity, but it has not re-visioned the notion of subjectivity itself. And now, even its success there comes in question as the patients' complaints

bespeak problems that are no longer merely sub-
jective in the former sense. For all the while that
psychotherapy has succeeded in raising the con-
sciousness of human subjectivity, the world in which
all subjectivities are set has fallen apart. Breakdown
is in a new place—Vietnam and Watergate, bank
scandals with government collusion, pollution and
streetcrime, the loss of literacy and the growth of
junk, deceit, and show. We now encounter pathology
in the psyche of politics and medicine, in language
and design, in the food we eat. Sickness is now 'out
there.'

The contemporary use of the word "breakdown"
shows what I mean. Nuclear power plants like Three
Mile Island and Chernobyl provide vivid examples of
possibly incurable, chronic breakdowns. The traffic
system, the school systems, the courts and criminal
justice system, giant industries, municipal govern-
ments, finance and banking—all undergo crises, suf-
fer breakdowns, or must be shored up against the
threat of collapse. The terms "collapse," "functional
disorder," "stagnation," "lowered productivity," "de-
pression," and "breakdown" are equally valid for
human persons and for objective public systems and
the things within the systems. Breakdown extends
to every component of civic life because civic life is
now a constructed life: we no longer live in a bio-
logical world where decay, fermentation, metamor-

phosis, catabolism are equivalents for the dysfunction of constructed things. My colleague and friend in Dallas Robert Sardello writes:

> The individual presented himself in the therapy room of the nineteenth century, and during the twentieth the patient suffering breakdown is the world itself. . . . The new symptoms are fragmentation, specialization, expertise, depression, inflation, loss of energy, jargoneze, and violence. Our buildings are anorexic, our business paranoid, our technology manic.

Wherever the language of psychopathology occurs (crisis, breakdown, collapse), the psyche is speaking of itself in pathologized terms, attesting to itself as subject of the *pathos*. As breakdown appears in all these symptoms of Sardello's list, so then does psyche or psychic reality. The world, because of its breakdown, is entering a new moment of consciousness: by drawing attention to itself by means of its symptoms, it is becoming aware of itself as a psychic reality. The world is now the subject of immense suffering, exhibiting acute and crass symptoms by means of which it defends itself against collapse. So it becomes the task of psychotherapy and its practitioners to take up that line initiated first by Freud:

the examination of culture with a pathological eye. At the conclusion to his *Civilization and Its Discontents,* Freud wrote:

> . . . there is one question which I can hardly evade. If the development of civilization has such . . . similarity to the development of the individual . . . may we not be justified in reaching the diagnosis that . . . some epochs of civilizations—possibly the whole of mankind— have become neurotic? An analytic dissection of such neuroses might lead to therapeutic recommendations which could lay claim to great practical interest.

Let us carry Freud's notion of neurosis and the therapeutic analysis of it beyond the community of individuals to the communal environment.

This examination, as well as the therapeutic eros that draws the practitioner into the world as patient, has been vitiated at the very start by tracing dysfunction in the world back to individual subjectivity. Depth psychology has argued that architecture cannot change, or politics or medicine, until architects, politicians, and doctors go into analysis. Depth psychology has insisted that the pathology of the world out there results simply from the pathology of the world in here. The world's disorders are man-

made, enactments and projections of human subjectivity.

Is this view not depth psychology's denial of things as they are so as to maintain its view of the world? Cannot psychology itself be unconscious of its own ego-defenses? If depth psychology is wrong on this count, then another of its defenses, its idea of projection, also needs reversing. Not only my pathology is projected onto the world; the world is inundating me with its unalleviated suffering. After one hundred years of the solitude of psychoanalysis, I am more conscious of what I project outward than what is projected onto me by the unconsciousness of the world.

Working with a patient two or even five hours a week, and extending this work into therapy of milieu, family, and office team, cannot prevent the spread of epidemic psychic infection. We cannot inoculate the individual soul nor isolate it against the illness in the soul of the world. A decaying marriage can be analyzed to its intra- and inter-subjective roots, but until we have also considered the materials and design of the rooms in which the marriage is set, the language in which it is spoken, the clothing in which it is presented, the food and money that are shared, the drugs and cosmetics used, the sounds and smells and tastes that daily enter the heart of that marriage—until psychology admits the world

into the sphere of psychic reality—there can be no amelioration, and, in fact, we are conspiring in the destruction of that marriage by loading onto the human relationship and the subjective sphere the repressed unconsciousness projecting from the world of things.

The inclusion of these matters into the therapy hour can have immediate practical effect. The married partners no longer focus only on themselves and their relationship. Together they turn their eyes to the indignities imposed on them by the world. Personal rage with each other turns to outrage, and even compassion, as they awaken from their anesthetized slumber of subjectivism. They emerge from the cave with a new sensitivity in the possibility of fellowship, comrades in arms, into the smogfilled sunlight which psychoanalysis had taught them was a place of mere shadows, only the scenery and machinery against which backdrop they played their inter- and intra-subjective drama. Now they can analyze social forces, environmental conditions, the designs of things on them with the same acuity they hitherto reserved only for themselves. Those who were in couple therapy become the therapeutic couple whose patient is their world.

ANIMA MUNDI

In place of the familiar notion of psychic reality based on a system of private experiencing subjects and dead public objects, I want to advance a view prevalent in many cultures (called primitive and animistic by Western cultural anthropologists), which also returned for a short while in ours at its glory through Florence and Marsilio Ficino. I am referring to the world soul of Platonism which means nothing less than the world ensouled.

Let us imagine the *anima mundi* neither above the world encircling it as a divine and remote emanation of spirit, a world of powers, archetypes, and principles transcendent to things, nor within the material world as its unifying panpsychic life-principle. Rather let us imagine the *anima mundi* as that particular soul-spark, that seminal image, which offers itself through each thing in its visible form. Then *anima mundi* indicates the animated possibilities presented by each event as it is, its sensuous presentation as a face bespeaking its interior image—in short, its availability to imagination, its presence as a *psychic* reality. Not only animals and plants ensouled as in the Romantic vision, but soul is given with each thing, God-given things of nature and man-made things of the street.

The world comes with shapes, colors, atmos-

pheres, textures—a display of self-presenting forms. All things show faces, the world not only a coded signature to be read for meaning, but a physiognomy to be faced. As expressive forms, things speak; they show the shape they are in. They announce themselves, bear witness to their presence: "Look, here we are." They regard us beyond how we may regard them, our perspectives, what we intend with them, and how we dispose of them. This imaginative claim on attention bespeaks a world ensouled. More— our imaginative recognition, the childlike act of imagining the world, animates the world and returns it to soul.

Then we realize that what psychology has had to call "projection" is simply animation, as this thing or that spontaneously comes alive, arrests our attention, draws us to it. This sudden illumination of the thing does not, however, depend on its formal, aesthetic proportion which makes it 'beautiful'; it depends rather upon the movements of the *anima mundi* animating her images and affecting our imagination. The soul of the thing corresponds or coalesces with ours. This insight that psychic reality *appears* in the expressive form or physiognomic quality of images allows psychology to escape from its entrapment in 'experience.' Ficino releases psychology from the self-enclosures of Augustine, Descartes, and Kant, and their successors, often Freud and sometimes Jung. For centuries we have iden-

tified interiority with reflexive experience. Of course, things are dead, said the old psychology, because they do not 'experience' (feelings, memories, intentions). They may be animated by our projections, but to imagine their projecting upon us and each other their ideas and demands, to regard them as storing memories or presenting their feeling characters in their sensate qualities—this is magical thinking. Because things do not experience, they have no subjectivity, no interiority, no depth. Depth psychology could go only to the intra- and interpersonal in search of the interiority of soul.

Not only does this view kill things by viewing them as dead; it imprisons us in that tight little cell of ego. When psychic reality is equated with experience, then ego becomes necessary to psychological logic. We have to invent an interior witness, an experiencer at the center of subjectivity—and we cannot imagine otherwise.

With things returned again to soul, their psychic reality given with the *anima mundi*, then their interiority and depth—and depth psychology too—depend not on their experiencing themselves or on their self-motivation but upon self-witness of another sort. An object bears witness to itself in the image it offers, and its depth lies in the complexities of this image. Its intentionality is substantive, given with its psychic reality, claiming but not requiring our witness. Each particular event, including

individual humans with our invisible thoughts, feelings, and intentions, reveals a soul in its imaginative display. Our human subjectivity too appears in our display. Subjectivity here is freed from literalization in reflexive experience and its fictive subject, the ego. Instead, each object a subject, and its self-reflection is its self-display, its radiance. Interiority, subjectivity, psychic depth—all out there, and so, too, psychopathology.

Hence, to call a business "paranoid" means to examine the way it presents itself in defensive postures, in systematizations and arcane codes, its delusional relations between its product and the speaking about its product, often necessitating gross distortions of the meanings of such words as good, honest, true, healthy, etc. To call a building "catatonic" or "anorexic" means to examine the way it presents itself, its behavioral display in its skinny, tall, rigid, bareboned structure, trimmed of fat, its glassy front and desexualized coldness and suppressed explosive rage, its hollow atrium interior sectioned by vertical shafts. To call consumption "manic" refers to instantaneity of satisfaction, rapid disposal, intolerance for interruption (flow-through consumption), the euphoria of buying without paying (credit cards), and the flight of ideas made visible and concrete in magazine and television advertising. To call agriculture "addictive" refers to its obsession with ever-higher yields, necessitating ever more chemical

energizers (fertilizers) and mass killers (pesticides, herbicides) at the expense of other life forms and to the exhaustion of agriculture's earthen body.

This new sense of psychic reality requires a new nose. More than the psychoanalytic nose that searches for depth of meaning and hidden connections, we need the nose of common animal sense, an aesthetic response to the world. This response ties the individual soul immediately with the world soul; I am animated by its anima, like an animal. I reenter the Platonic cosmos which always recognizes that the soul of the individual can never advance beyond the soul of the world, because they are inseparable, the one always implicating the other. Any alteration in the human psyche resonates with a change in the psyche of the world.

We have tried hitherto in depth psychology to regain the psyche of the world by subjectivist interpretations. The stalled car and blocked driveway became my energy problems; the gaping red construction site became the new *operatio* going on in my adamic body or an opening to the female. We could give subjectivity to the world of objects only by taking them into our interior subject, as if they were expressing our complaint. But that stalled car, whether in my dream or in my driveway, is still a thing unable to fulfill its intention; it remains there, stuck, disordered, claiming attention for itself. The great wound in the red earth, whether in my dream or

in my neighborhood, is still a site of wrenching up-heaval, appealing for an aesthetic as much as a hermeneutic response. To interpret the world's things as if they were our dreams deprives the world of its dream, its complaint. Although this move may have been a step toward recognizing the interiority of things, it finally fails because of the identification of interiority with only human subjective experience.

Does this mean that psychotherapists will now analyze their couches? Will they now point out to their office ventilating-machines that these on-and-off blowhard persons interrupt conversations with an inconsiderately timed and passive-aggressive cold monotone? Do we now analyze the car and deposit the drivers in a day-care lot? Not quite. But let me suggest what we can do with this extended view of psychic reality.

AISTHESIS

We can respond from the heart, reawaken the heart. In the ancient world the organ of perception was the heart. The heart was immediately connected to things via the senses. The word for perception or sensation in Greek was *aisthesis,* which means at root a breathing in or taking in of the world, the gasp, "aha," the "uh" of the breath in wonder, shock, amazement, an aesthetic response to the image (*eidolon*) presented. In ancient Greek physiology and in biblical psychology the heart was the organ of sensation: it was also the place of imagination. The common sense (*sensus communis*) was lodged in and around the heart, and its role was to apprehend images. For Marsilio Ficino, too, the spirit in the heart received and transmitted the impression of the senses. The heart's function was aesthetic.

Sensing the world and imagining the world are not divided in the aesthetic response of the heart as in our later psychologies deriving from Scholastics, Cartesians, and British empiricists. Their notions abetted the murder of the world's soul by cutting apart the heart's natural activity into sensing facts on one side and intuiting fantasies on the other, leaving us images without bodies and bodies without images, an immaterial subjective imagination severed from an extended world of dead ob-

jective facts. But the heart's way of perceiving is both a sensing and an imagining: to sense penetratingly we must imagine, and to imagine accurately we must sense.

By "heart" I do not mean the sentimental subjectivism that came as a Romantic consequent of the loss of *aisthesis*. I am not talking of body-feelings in a simplistic psychology—whatever I feel is good; deep down inside my heart, I'm okay; what comes from the heart is good per se. Let us keep to one side these more familiar meanings of heart: the pump-and-muscle idea, the Augustinian-confession idea, the religious-conversion idea, the Valentine-love idea. Each has its history and its reason. Let us stay with the aesthetic heart of our ancient and Florentine tradition.

It is this heart I am trying to awaken in an aesthetic response to the world. The *anima mundi* is simply not perceived if the organ of this perception remains unconscious by being conceived only as a physical pump or a personal chamber of feelings.

Awakening the imagining, sensing heart would move psychology itself from mental reflection toward cordial reflex. Psychology may then become again Florentine; for the move 'southward' that I have been urging these last twenty years—from the clinics of Zürich and Vienna, from the white laboratories and black forests of Germany, from the positivist and empiricist dissections of Britain and

America, to say nothing of the gymnastics of the tongue in France—cannot be accomplished without moving as well the seat of the soul from brain to heart and the method of psychology from cognitive understanding to aesthetic sensitivity. With the heart we move at once into imagination. For when the brain is considered to be the seat of consciousness we search for literal locations, whereas we cannot take the heart with the same physiological literalism. The move to the heart is already a move of *poesis:* metaphorical, psychological.

Another organ and another method move psychology to another altar, Venus. In addition to Saturn, systems, and fathers, in addition to ego-development and heroics of Mother and Child, or Apollonic elucidation and medical detachment, or Minerva and grey-eyed practical counseling, or Dionysian participation in communal soul, or Hermes' transactions and mediating communication—there is also Aphrodite who was called the world soul in Ficino's translation of Plotinus and to whom Ficino awards the sensate world. To grasp the Greek account of perception, psychology must already, as did Psyche in Apuleius's tale, stand in the temple of Aphrodite, recognizing that each thing smiles, has allure, calls forth *aisthesis.* "Calling forth," provoking, *kaleo:* this was Ficino's derivation of Aphrodite's main characteristic, *kallos*, beauty.

If we could reoriginate psychology at its Western

source in Florence, a way might open again toward a meta-psychology that is a cosmology, a poetic vision of the cosmos which fulfills the soul's need for placing itself in the vast scheme of things. This has been impossible so long as psychology had its home in the alien 'north,' where cosmology was absorbed by ontology and metaphysics, conceptual systems without aesthetic images, without myths and faces of the Gods, without pathologized images — an alienation that distorted the soul's care into an alienist's cure.

To come back to our own heart, its stirrings as it comes to consciousness may be a crucial contributing factor in contemporary heart and circulatory disorders. Puzzling symptoms have often ushered in new eras of psychological awareness: hysteria and Freud, schizophrenia and Jung. . . . If we live in a world whose soul is sick, then the organ which daily encounters this sick world-soul first and directly through *aisthesis* will also suffer as will the circulatory channels which transmit perceptions to the heart. Psychotherapy needs to affirm the sufferings of the heart, its dis-ease in the world of things, that they are ugly, empty, wrong, bereft of a sense-making cosmos, and by this affirmation that yes we are heart-sick because we are thing-sick, psychotherapy will lift the an-esthetized stupor from our reactions, lift the repression in the ugliness of things themselves, so that psychotherapy can move again,

as it always must do, in the direction that the symptoms are leading it, now toward an appreciation of the world ensouled.

The so-called "number one killers" cannot be restricted to heart disease and cancer. Death lurks in things: asbestos and food-additives, acid rain and tampons, insecticides and pharmaceuticals, car exhausts and sweeteners, televisions and ions. Matter is more demonized than ever it was in the plague. We read labels of warning, feel invisible evils descend through the air, infiltrate the water, and permeate our vegetable sustenance. The material world is inhabited again; the repressed returns from the matter declared dead by Aquinas and Descartes, now as Death itself, and because of this resurrecting ghost in matter we are aware at last again of the *anima mundi*. Psychology always advances its consciousness by means of pathologized revelations, through the Underworld of anxiety. Our ecological fears announce that *things* are where the soul now claims psychological attention.

Things are composed of poisonous and flammable substances, stamped out of uniform molds, internally fastened cheaply, quickly with the least care, untouched by the human hand. They cannot weather or age. Their existence is hurried by the push of obsolescence as one generation succeeds the next within a few months. Sold by barkers on the slave-blocks of the market, competing by price only

and not by pride or inherent beauty, their suffering is written on their faces. The postures of their strange-shaped bodies, like figures in Hell, show them cursed by the materialism in whose image they have been made, with no *epistrophé* possible, no way back to the Gods.

To move with the heart toward the world shifts psychotherapy from conceiving itself as a science to imagining itself more like an aesthetic activity. If unconsciousness can be redefined as insensitivity and the unconscious as the an-esthetic, then training for psychotherapy requires sophistication of perception. Training will be based in the imagining, sensing heart: call it forth and educate it. Psychotherapy will study in its training programs the embodiments of the *anima mundi,* whether in language, in arts, or rituals, attempting to train the eye and ear, nose and hand to sense truly, to make right moves, right reflexive acts, to craft well. The invisible work of making soul will find its analogies in the visibility of well-made things. The cognitive task will shift from the understanding of meaning to a sensitization to particulars, the appreciation of the inherent intelligibility given in the qualitative patterns of events. We will recognize health of soul by its aesthetic response in which judgment always inheres, rather than separating out the judgments into moral (good and bad), medical (ill and well, progress

and regress), or logical (true and false) assessments. Humanistic education as conceived in Florence becomes a necessity again: differentiated language, fine arts, handworks, biography, criticism, history, cultural anthropology, manners and customs, life among things of the world. And our questions will be addressed to *what* things are, and *where*, and *who*, and in *which* precise way they are as they are, rather than *why, how come*, and *what for*.

Please, let me insist: by aesthetic response I do not mean beautifying. I do not mean planting trees and going to the galleries. I do not mean gentility, soft background music, clipped hedges—that sanitized, deodorized use of the word "aesthetic" that has deprived it of its teeth and tongue and fingers. Beauty, ugliness, and art are neither the full content nor true base of aesthetics. In the Neoplatonic understanding, beauty is simply manifestation, the display of phenomena, the *appearance* of the *anima mundi;* were there no beauty, the Gods, virtues, and forms could not be revealed. Beauty is an epistemological necessity; *aisthesis* is how we know the world. And Aphrodite is the lure, the nudity of things as they show themselves to the sensuous imagination.

Thus, what I do mean by aesthetic response is closer to an animal sense of the world—a nose for the displayed intelligibility of things, their sound, smell, shape, speaking to and through our heart's

reactions, responding to the looks and language, tones and gestures of the things we move among.

Thing-consciousness could extend the notion of self-consciousness from the constrictions of subjectivism. An analyst sitting in his chair all day long is more aware of the faintest flickers of arousal in the seat of his sexuality than of the massive discomfort in the same seat brought by the chair: its wrongly built back, its heat-retaining fabric, its resistant upholstery and formaldehyde glue. His animal sense has been trained to notice only one set of proprioceptions to the exclusion of the psychic reality of the chair. A cat knows better.

SOME POSITIVE EFFECTS

Cultivation of the aesthetic response will affect issues of civilization that most concern us today and which have remained largely intractable to psychological resolution. First, an aesthetic response to particulars would radically slow us down. To notice each event would limit our appetite for events, and this very slowing down of consumption would affect inflation, hyper-growth, the manic defenses and expansionism of the civilization. Perhaps, events speed up in proportion to their not being appreciated; perhaps events grow to cataclysmic size and intensity in proportion to their not being noticed. Perhaps, as the senses become refined, there is a scaling down of gigantism and titanism, those mythically perennial enemies—giants and titans—of culture.

Attention to the qualities of things resurrects the old idea of *notitia* as a primary activity of the soul. *Notitia* refers to that capacity to form true notions of things from attentive noticing. It is the full acquaintance on which knowledge depends. In depth psychology, *notitia* has been limited by our subjective view of psychic reality so that attention is refined mainly in regard to subjective states. This shows in our usual language of descriptions. When for in-

stance I am asked, "How was the bus ride?" I respond, "Miserable, terrible, desperate." But these words describe me, my feelings, my experience, not the bus ride which was bumpy, crowded, steamy, cramped, noxious, with long waits. Even if I noticed the bus and the trip, my language transferred this attention to notions about myself. The 'I' has swallowed the bus, and my knowledge of the external world has become a subjective report of my feelings.

An aesthetic response does require these feelings but it cannot remain in them; it needs to move back to the image. And the way back to the bus ride necessitates words which notice its qualities.

Since the Enlightenment our adjectives have moved from qualifying the world to describing the self—fascinating, interesting, boring, exciting, depressing; these words neglect the things that evoke the subjective states, and even the states have lost the precision of image, metaphor, and simile. A restoration of soul to world means knowing things in that further sense of *notitia:* intimate intercourse, carnal knowledge. The appreciation of the *anima mundi* requires adverbs and adjectives that precisely imagine the particular events of the world in particular images, much as the ancient Gods were known through their adverbial and adjectival epithets—grey-eyed Athene, red-faced Mars, swift-footed, chaste Artemis. To perceive the value of things and the virtues in them requires a language

of values and virtues, a return of the secondary qualities to things—colors, textures, tastes.

This 'adjectival revolution' would overthrow the canon of good writing, the ascetic puritanism—"plainness, simplicity, orderliness, sincerity"—of Strunk and White and of Fowler (in English), that contemporary form of Protestant iconoclasm which bans the adornment of adjectives and adverbs in favor of bare nouns and verbs making definite assertions in the active voice—a grammatical world of heroic subjects doing things to objects, without ambiguity, passivity, or reflexiveness.

These rules of style, so innocently straightforward and unmetaphysical, actually deface the world's physiognomic characters and keep our consciousness within the dead-worldview where all qualities, according to the main line of Western philosophy, refer only to changes in the subject. The world only seems to lie about us, so beautiful, so various, so new, for as Hume wrote: "all the sensible qualities of objects, such as hard, soft, hot, cold, white, black, etc. are merely secondary, and exist not in the objects themselves, but are perceptions of the mind, without any external archetype or model, which they represent." And Kant continued: "The taste of a wine does not belong to the . . . wine . . . but to the special constitution of sense in the subject that tastes it. Colours are not properties of the bodies . . . but only modifications of the sense of sight."

The improvement of the quality of life depends on a restoration of a language which notices the properties of bodies, the qualities of life.

Our way back to the bus thus leads back to the Renaissance insistence on rhetoric, incorporating along the way the poetic methods of Imagism, Concretism, Objectivism, Projective Verse—modes of language that do not dwell in 'experience' and which instead enliven things, giving them back their animated faces.

Second, that unspoken religious fervor in psychotherapy would shift its focus from saving the soul in the personal patient to saving the soul of the world, the resurrection of the world rather than the resurrection of man, the celebration of creation before the redemption of creativity in the individual. Here I refer again to Ficino, who writes that "Creation is a more excellent act than illumination," so that the task of "raising consciousness" (as redemption of the soul is now disguised in modern therapy) becomes a raising of consciousness of created things, a therapy of the constructed world's psychic reality.

This new focus would affect the ecology movement and such 'mundane matters' as energy policy, nourishment, hospital care, the design of interiors. No longer would these be external—that is, political or professional—activities only but a focus of psychotherapy, because no longer would we be able to

divorce consciousness-raising of the patient from the creation itself, while illumination of the patient would be contingent upon therapy of the creation. This larger sense of therapy begins in the smaller acts of noticing.

A third positive effect would return value from the subject to the thing, where it has been pre-empted by price. The most universal of all modern religions, economics, has appropriated into its literalism the sense of value, removing psychic reality from credit, trust, interest, inflation, and the like. We buy in order to save, as saving has been reduced utterly to an economic term. Appreciation, too, the very key to *aisthesis,* more commonly refers to a higher price. As value capitulates to price, the symbolic numbers of psychic import, the threes, sevens, tens, twelves are sold out to ninety-five, ninety-eight, or ninety-nine in a fractional debasement of whole digits like the chips and filings off true coins.

If soul value can be found only in the safe of psychotherapy, its price will rise, while the things with which we live—underwear, auto tires, place-mats, pillow cases—get cheaper. Recognition that the soul is also in the world may awaken us from the psychotherapeutic trance in which we pay a hundred dollars for an hour of subjectivism and no more than $19.95 for a beach chair in whose cold metallic arms and plastic lap reflection actually takes place, day after day. What use becoming conscious

in analysis and remaining anesthetized to the chair? Were the chair better value, were it cooperating in soul-making, would analysis still be so valuable, so dear?

Fourth, we might be relieved of the desperation for intimacy, the transference clutch, the narrow personalization of love, the fear of loneliness. This because, as William James saw, intimacy occurs when we live in a world of particular, concrete events, noticeable for what he called their "eachness." Each thing bears "importance" in Whitehead's sense. Or in Ortega's sense, only personified, individualized things can be loved. The aesthetic response is never a fuzzy pantheism, a generalized adoration of nature or even of the city. Rather it is that joyful scrutiny of detail, that intimacy of each with each such as lovers know. Here, individuation itself moves from the individualized realization of self to the individuation of matter.

A world without soul offers no intimacy. Things are left out in the cold, each object by definition cast away even before it is manufactured, lifeless litter and junk, taking its value wholly from my consumptive desire to have and to hold, wholly dependent on the subject to breathe it into life with personal desire. When particulars have no essential virtue, then my own virtue as a particular depends wholly and only on my subjectivity or on your desire

for me, or fear of me: I must be desirable, attractive, a sex-object, or win importance and power. For without these investments in my particular person, coming either from your subjectivity or my own, I too am but a dead thing among dead things, potentially forever lonely.

If particulars—whether images, things, or the events of the day—are to afford significance, the burden has been on the subject to maintain libidinal cathexes, "to relate," so that depersonalization and derealization do not occur. It has been up to us to keep the world aglow. Yet these syndromes, depersonalization and derealization, are latent in the theory of the external world as soulless. Of course I am lonely, unrelated, and my existence throwaway. Of course therapy must focus on relations rather than on contents, substantialities, things that matter, because connection becomes the main work of therapy when the world is dead: ego psychology is inevitable, for the patient must find ways to connect the psyche of dream and feeling to the dead world so as to reanimate it. What stress, what effort it takes to live in a cemetery; what terrible need for willpower. So of course I fall prey to ideologies and cults that relieve the burden of this subjectivity. Of course I am in desperate narcissistic need, not because I have been neglected or still neglect my inmost subjectivity, but because the world without soul can

never offer intimacy, never return my glance, never look at me with appeal, with gratitude, nor relieve the essential isolation of my subjectivity.

But at that moment when each thing, each event presents itself again as a psychic reality—which does not require the magics of synchronicity, religious fetishism, or any special symbolic act—then I am held in an enduring intimate conversation with matter. Then grammar breaks its hold: subject and object, personal and impersonal, I and thou, masculine and feminine find new modes of intermingling; plural verbs may disagree with their singular nouns as the imagination in things speaks its language to the heart. Then Eros descends from being a universal principle, an abstraction of desire, into the actual erotics of sensuous qualities in things: materials, shapes, motions, rhythms.

A fifth despair of our civilization would also be radically affected by this turn toward the world soul. This issue, technology, would no longer be contrasted romantically with nature, technology bad and nature good, cities bad and country good, soul in trees but not in the saws that cut them. Rather, all things, whether constructed or natural, by presenting their virtues carry soul.

When I look to history for a model for this soul in manufactured things, I make a classical, renaissance move: I turn back to ancient Egypt. There, *l'objet parlant* was common to hand. Each thing spoke

of the Gods which were inherent in all actualities from a cosmetic box, a beaker, or a jar to the river and the desert. Even where things were made in innumerable multiples, thousands cast from the same molds, they were each a speaking object. It is not numerical singularity that guarantees uniqueness; rather, eachness derives from the imaginal potential, the God, in the thing.

Technology is not necessarily the enemy of the heart; technology is not inherently soulless. We are less endangered by the brute facts of nuclear, genetic, computer, and chemical technology as such than we are by the brute anesthetized conception of these technical inventions as soulless mechanisms. Because they are conceived in the Cartesian-Christian fantasy, they become objective, brute, and mute. Technical inventions have become the great repressed slaves, obedient to mechanical laws, disallowed breakdown, and so we fear them. We want the most from them at the least cost. Because the paradigm of our mindset allows soul only to subjective persons, technology is not considered part of what Whitehead calls "nature alive," a realm of speaking objects with faces, and is instead a fearful Frankenstein monster. Technology becomes psychopathological when, like any other phenomenon, it is deprived of soul, as it has been by the very theoretical assumptions that gave birth to it in the first place. It was monstrously conceived. But now cheeky,

perky R2D2 has replaced Boris Karloff. The Monster subsides along with Newtonian mechanism. Technology can be reconsidered, each thing imagined anew in terms of *anima mundi*.

CONCLUDING AFFIRMATIONS

Catastrophe fantasies haunt us; they announce the end of the world. As with suicide fantasies we must ask them precisely what world is coming to its end. An answer comes hard because we take the fantasies so literally that we can barely sit with them for more than a moment. Anesthesia: Robert J. Lifton calls it "psychic numbing." And we are drugged not only by the industry of distillers, dope-runners, pharmaceutical firms, and pill-prescribing physicians. We are anesthetized as well by the subjectivism of psychotherapy, as if the end-of-the-world were an 'inner problem.'

The very literalism of the catastrophe fantasies hint at what world is coming to an end. They fulfill the Christian apocalyptic vision, and they fulfill all too literally the doctrine of a world already declared dead by the Western tradition, a world over whose autopsy the Western, Northern mind has been presiding since Newton and Descartes. Can we now see what Blake always knew: the apocalypse that kills the soul of the world is not at the end of time, not coming, but apocalypse now; and Newton and Locke, Descartes and Kant are its Horsemen. The fantasies of the literal end of the world announce, however, the end of this literalist world, the dead, objective world. As such, the catastrophe fantasies

also reflect an iconoclastic process of the psyche which would smash the soulless mechanical idol of the world that we have worshiped ever since Christ said his Kingdom is not of this world and left it to the legions of Caesar, so that the aesthetic, imaginative, polytheistic animation of the material world was cursed into demonism and heresy, while psychology allowed psyche only to self-reflective confessional egos, inflating them to titanic monstrosity.

That vast insensate edifice—the doctrine of a soulless world—now streaked with acid rain and stained by graffiti has in our fantasies already exploded into dust. Yet, that cataclysm, that pathologized image of the world destroyed, is awakening again a recognition of the soul in the world. The *anima mundi* stirs our hearts to respond: we are at last, *in extremis,* concerned about the world; love for it arising, material things again lovable. For where there is pathology there is psyche, and where psyche, eros. The things of the world again become precious, desirable, even pitiable in their millennial suffering from Western humanity's hubristic insult to material things.

Ecology movements, futurism, feminism, urbanism, protest and disarmament, personal individuation cannot alone save the world from the catastrophe inherent in our very idea of the world. They require a cosmological vision that saves the phenomenon 'world' itself, a move in soul that goes

beyond measures of expediency to the archetypal source of our world's continuing peril: the fateful neglect, the repression, of the *anima mundi*.

Repressed, yet there nonetheless; for an idea of the soul of the world runs through all Western thought, to say nothing of archaic, primitive, and oriental cultures, so that what I have been asking you to entertain is neither altogether radical nor new. It is affirmed in differing ways in Plato, the Stoics, Plotinus, and in Jewish and Christian mystics; it appears splendidly in the Renaissance psychology of Marsilio Ficino, in Swedenborg; it is revered in Mariology, Sophianic devotion, in the Shekinah. We find notions of it in German and British Romantics and American transcendentalists; in philosophers of various sorts of panpsychism from Leibniz through Peirce, Schiller, Whitehead, and Hartshorne. The world soul returns also in the pluralistic position of William James, through his interest in Fechner and his concern for "the particular, the personal, and the unwholesome," or the "eachness" of events rather than abstracted wholes. *Anima mundi* reappears in further guises as "the collective" in Jung, as physiognomic character in the Gestalt psychology of Koffka and Köhler, in the phenomenology of Merleau-Ponty, of van den Berg, in the poetics of matter and space in Bachelard, and even in Roland Barthes, and of course, ever and again in the great poets, specifically of this century in Yeats and

Rilke and Wallace Stevens. What I have been proposing has a noble inheritance, and I cite these names not only to show the pedigree of the idea, but to suggest that it is the *anima mundi* that gives these names their nobility.

For all this, the psychic reality of the world of things seems a strange idea in psychotherapy, because *anima mundi* does not occur in the tradition from which psychotherapy believes it stems: eighteenth-century enlightenment and nineteenth-century science and their offspring, therapy's cousins: positivism, materialism, secularism, nominalism, reductionism, personalism, behaviorism.

Hence to rework our notion of psychic reality implicates each of us in reworking our background, the tradition which continues to feed our theory-forming and our idea of reality. I urge that the tradition to which we must turn in face of the fantasies of cataclysm lies not in the Himalayas, not on Mt. Athos, or the far planets of space, nor does it lie in nihilistic terror that foreshadows the cataclysm; it dwells in the imagining heart of the Renaissance city, in its streets, in its language, its things, in the city of the heart of the world.

We will not be able to move in this direction until we have made radical shifts of orientation, so that we can value soul before mind, image before feeling, each before all, *aisthesis* and imagining before *logos* and conceiving, thing before meaning, notic-

ing before knowing, rhetoric before truth, animal before human, anima before ego, what and who before why. We would have to let fall such games as subject-object, left-right, inner-outer, masculine-feminine, immanence-transcendence, mind-body—the game of oppositions altogether. A great deal of what we now hold dear would break down so that the emotion held by these cherished relics could break those vessels and flow back into the world.

Breaking the vessels is the return, the turn again to the world, giving back what we have taken from it by storing inside ourselves its soul. By this return we regard the world anew, having regard for it as it shows its regard for us and to us in its face. We pay respect to it simply by looking again, re-specting, that second look with the eye of the heart.

This respect demands reconstitution of our language so that it speaks again of qualities—naming what is there, rather than what we feel about what is there and abstraction away from what is there. Language with referents that are not mere objective correlatives of our emotions or mere objective descriptions. Instead, the emptied sense of our words would be refilled by concrete images, our talk, an animal talk, echoing the world.

Finally, we would have to consider that the entire intra-subjective model with which psychotherapy works—psychodynamics, psychopathology, the unconscious, even personality itself—might also apply

to the world and its things. For if the world is en-
souled, then the language psychoanalysis has devel-
oped for psyche is also appropriate to the world and
its objects. To pursue this re-vision of psychic reality
implies that we shall have to let our present sustain-
ing paradigm break down, a catastrophe of the mind
rather than of the world, allowing to emerge a
renaissance of soul in the midst of the world, and
with it, from the depths of its breakdown and ours,
a renaissance of psychology.

Psychology Beyond the Consulting Room

Inter Views: Conversations on Psychotherapy, Biography,
Love, Soul, Dreams, Work, Imagination . . .
JAMES HILLMAN (with Laura Pozzo)

Extraordinary, yet practical accounts of active imagination,
writing, daily work, symptoms, and sufferings in their rela-
tion with loving. The only biography of Hillman, the book
also radically deconstructs the interview form itself. William
Kotzwinkle: "*Inter Views* is a lens focused by the bright gods,
the archetypes, with whom Hillman is in creative rapport."
(198 pp.)

The Greening of Psychology: The Vegetable World
in Myth, Dream, and Healing
PETER BISHOP

Revives the fertile but deeply downward and uncanny roots
of our vegetable soul, thereby radically dislocating our usual
assumptions about consciousness. Explores the vegetative
nervous system and its symptoms (reading anew Freud, Jung,
Reich), addictions to plant concoctions (cocaine, coffee,
sugar, etc.), social rootlessness, the worship of growth, and
the fear of rot. Illustrations, index. (237 pp.)

Archetypal Medicine
ALFRED J. ZIEGLER

Packed with case examples and medical data, this book of-
fers psychological readings of asthma, skin disease, heart
attacks, anorexia, rheumatism, and chronic pain. Challenges
the philosophical basis of traditional medicine, exposes its
shadow, and charges that the excessive interest in health
betrays humanity's deepest nature which is neither natural
nor healthy but instead afflicted and chronically ill. (169 pp.)

Spring Publications, Inc. P.O. Box 222069
Dallas, TX 75222